Intelligence Grow Mem

the *Painted*

WORD

MIXED MEDIA **LETTERING** TECHNIQUES

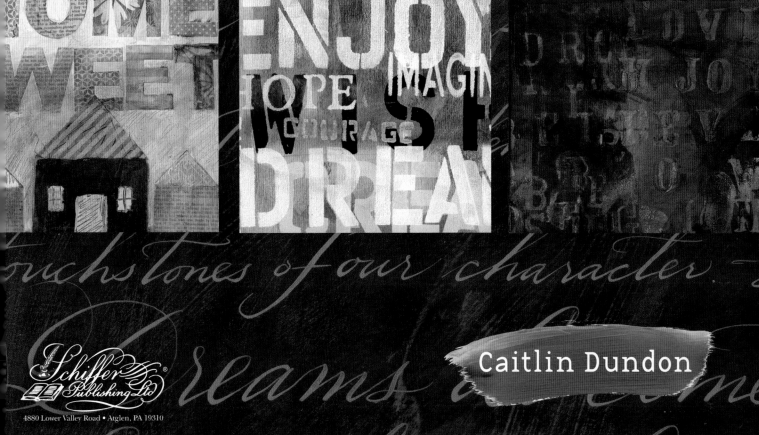

touchstones of our character

Caitlin Dundon

Schiffer Publishing Ltd

4880 Lower Valley Road • Atglen, PA 19310

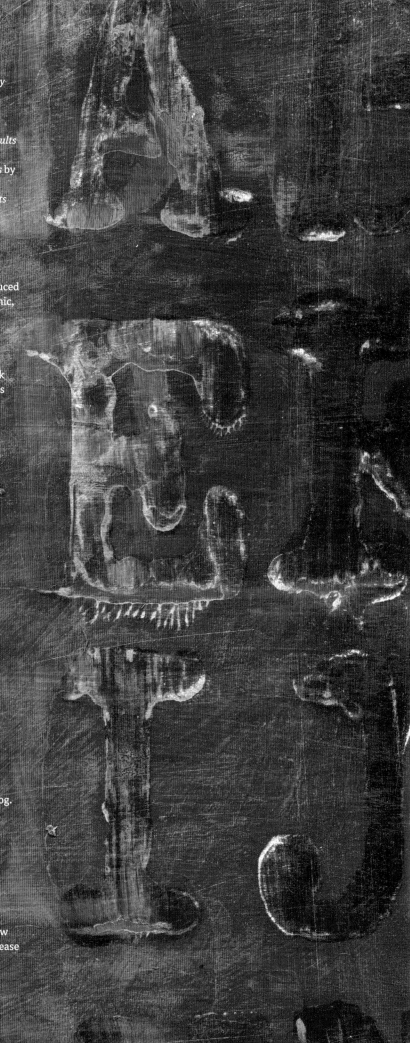

Photos by Caitlin Dundon
Author photo (back cover) by Nityia Photography
Designed by Molly Shields
Cover design by Caitlin Dundon and Ro S
Type set in Billy Ohio/Utopia Std

ISBN: 978-0-7643-5647-6
Printed in China

Published by Schiffer Publishing, Ltd.
4880 Lower Valley Road
Atglen, PA 19310
Phone: (610) 593-1777; Fax: (610) 593-2002
E-mail: Info@schifferbooks.com
Web: www.schifferbooks.com

For our complete selection of fine books on this and related subjects, please visit our website at www.schifferbooks.com. You may also write for a free catalog.

Schiffer Publishing's titles are available at special discounts for bulk purchases for sales promotions or premiums. Special editions, including personalized covers, corporate imprints, and excerpts, can be created in large quantities for special needs. For more information, contact the publisher.

We are always looking for people to write books on new and related subjects. If you have an idea for a book, please contact us at proposals@schifferbooks.com.

To my father, who instilled in me a love of words.

To my mother, who encouraged me to make art every day.

To my husband, who loves me even though I sometimes

come home covered with paint.

Contents

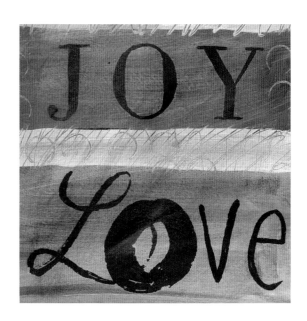

...is home...

Oliver Wendell Holmes "Home is the place where, when you have to

...Robert Frost To love and be loved will be the greatest event in

Home is not where you live, but where they understand you.

...tern. Sweet is the smile of home, the mutual look when

...other sure. —John Keble Love doesn't make the world go

...hat makes the ride worthwhile. —Franklin P. Jones But every

...bides, And Friendship is a guest, Is surely home, and home

...is the heart can rest. —Henry van Dyke A little peaceful home

...and wishes; add to this my book and friend—and this is

—Montaigne. Be glad of life because it gives us the chance

...Work and to look up at the stars. Henry van Dyke Where

...e heart, there is always room in the house. —Thomas Moore

...he world over in search of what he needs and returns

—George Moore Being deeply loved by someone gives

...e loving someone deeply gives you courage. —Lao Tzu

...d public that we may roam, Be it ever so humble,

...lace like Home. —John Howard Payne Where there

...ife. —Mahatma Gandhi Home is where there's

Home is where there's one to Love us! —Charles Swain

...g someone to live with, it's finding someone you can't live

...l Ortiz And hand in hand, on the edge of the sand,

...the light of the moon. —Edward Lear Home is

...T. S. Eliot Love is the beauty of the Soul. —Saint Augustine

INTRODUCTION

lettering in mixed media art

From the simple thoughts like "Live, Love, Laugh," to whole paragraphs, words and lettering have been showing up in illustrations and commercial art for years. But the popularity of adding sentiment through some form of lettering has increased in the last decade as artists want to add a deeper meaning to their artwork.

Handwriting can be a lovely addition to your art, and even simple printed or stamped text can help convey a mood. In this book, I will offer more than 48 techniques to use calligraphy, handmade lettering, and printed text in your art. From working with textural backgrounds with recycled bits of old novels, inscribed words, rubber-stamped phrases, and collaged-printed sentences, to applying your own calligraphy by hand, there are many creative ways to add lettering to art.

Subjects covered will include basic mixed media collage using found lettering from magazines, old books, etc.; cut paper collaged lettering; painted lettering; stamped and embossed lettering; gel plate and block printed lettering; and handwritten or inscribed lettering using conventional lettering tools, as well as some unconventional writing tools.

This isn't a book about calligraphy with dry tutorials on the use of pen and ink and perfect alphabet guides—it is an exploration of lettering as it applies to mixed-media art and ways to embrace lettering with the same passion and commitment to explore that you use to approach art. Non-calligraphers can use found, printed, stick-on, and stamped type, but I will also encourage everyone to pick up a brush pen or pointed pen and give it a try. Don't worry about making mistakes. The beauty of working over acrylic paint is that often if mistakes are made they can be removed, wiped away, sanded off, or painted over.

You'll learn how-to steps for many techniques, but you'll also find inspirational finished art using mixed-media lettering in various forms. It's my hope that you will explore and expand the ways you use tools in combination with color, paint, and collage. For those of you who aren't comfortable using your own handwriting, you can play with the various creative techniques with text and stamping and create some amazing art and inspiration with the painted word. Enjoy.

Caitlin Dundon

Where We Love Is Home. **Techniques used: decorative paper and old novel newsprint collage with acrylic soft gel, Golden high flow carbon black applied with pointed pen on wood panel.**

We become what we behold.
We shape our tools, and
thereafter our tools shape us.
 —Marshall McLuhan

Caitlin Dundon

TOOLS, MEDIUMS, AND SURFACES

There is always something more that you can buy, something more that you need, but keep in mind that many of the techniques in this book require only a few basics: white acrylic gesso, a 1" flat brush, and acrylic paint in a couple of colors. For collage techniques you will need either matte medium or acrylic gel. Build your artist tool kit as you go; donate supplies to others if you discover your passions lie elsewhere. You do not have to go out and buy the most expensive tools—a ballpoint pen works just about the same as an embossing tool for our purposes. Cheap brushes lend themselves to unusual stroke marks that can be beautiful. Just make sure you don't have a brush so cheap that it leaves brush hairs in your art, unless you want to collage them too! When buying paints, if you don't already have any fine art acrylics, such as Golden Heavy Body or Fluid, I would suggest buying a few to work with. Fine art acrylics have beautiful and deep pigments that really glow, especially when they are layered with sheer color washes and glazes. Sometimes I like a certain color in one brand of paint than another. I like the fluid and matte quality of DecoArt craft acrylics for gel plate printing but love the luminosity of Golden fluids too. If you need extra time for some techniques, you might consider buying open paints that allow longer working time before they dry, or using a slowing agent. The example projects in this book use either watercolor paper or wood panel as the substrate, which is another word for the surface you are painting on. I find it is very freeing to work on paper rather than on expensive canvas or wood panel. You can always mount your paper masterpiece to a wood panel, collage it to a canvas, or frame it later. Enjoy the process of exploration as you learn and play. Remember that many mistakes are just discoveries of another new technique or variation. I hope that you can make your own great discoveries.

Artist's and Printmaker's Tools and Mediums

acrylic glazing liquid
acrylic paints (heavy body, craft, fluid, high flow)
acrylic soft gel matte
block printing carving tool (Speedball)
brayer
brushes: ¼" flat, ½" flat, 1" mop brush, 1" flat brush, small assorted pointed brushes, liner brush
Caran D'Ache water-soluble pencils (white or light blue)
China Markers (white and black)
frisket eraser or adhesive pick-up square
gel printing plate (any size)
gesso (white and black)
graphite transfer paper (Saral)
Inktense blocks
masking fluid (Incredible White Mask Liquid Frisket)
matte medium
Micron pens (assorted sizes)
palette knife
palette paper
pencil (graphite)
PITT India Ink Big Brush Pen (white and black)
PITT Indian Ink pens (Faber Castell), (black assorted sizes)
rubber stamp for hand carving
ruler
scissors
self-healing cutting pad
silicone brush tool (Colour Shapers)
silicone wedges
tracing paper
X-Acto knife

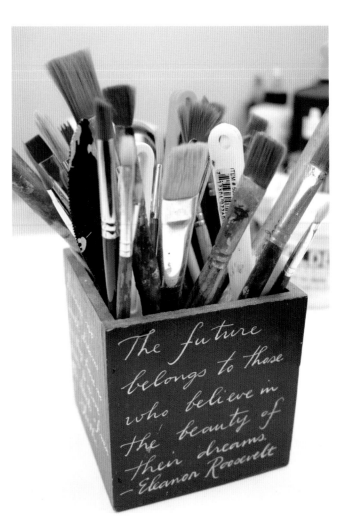

In Focus: Acrylic Paints

Acrylic paints come in many brands as well as consistencies that may be very confusing, but they all have different and wonderful uses. Basic acrylic paint categories include: craft acrylics, professional grade heavy body acrylics, fluid acrylics, and high flow. Fine art or professional grade heavy body acrylics (sold in tubes or jars) will have the most pigment or color and , therefore, are usually the most expensive. But they are worth it, since the pigment is gorgeous and just about glows even when thinned with water or matte medium. They have a buttery consistency and are well worth the cost, even if you just start with a fee of colors. Fluid acrylics are a thinner or runnier consistency, which is useful for printing and applying through stencils or using for washes. They are sold in bottles so they are easier to use to drip some paint directly onto your surface or to add a tint of color to gesso or glazing liquid. I love craft acrylics (sold in bottles) for adding large areas of flat color. They are also faster drying for using with a gel plate press, but they are more opaque than fluid paints. High flow is the thinnest of paints and functions more like an ink; it is fantastic for detail work, for lettering, and for use in dip pens.

Stamp, Stencil, and Scrapbook Tools and Mediums

decorative paper
embossing pens (black and clear)
embossing powders
embossing stamp pad (tinted)
embossing tool
foam pouncers
heat gun (tool)
mini mister or spray bottle
rubber stamps (alphabet, words, patterns)
StazOn permanent stamp pad (black)
StazOn stamp pad cleaner
stencils (alphabet, words, patterns)
stick-on alphabet letters
stick-on foam letters
wax resist stick

Calligraphy Tools and Mediums

acrylic ink (Daley Rowney FW)
Aquash
Canson Marker Layout paper
high flow paint (Golden) carbon black
Calligraphie or CalliCreative Italic White Markers
penholder
Pentel Color Brush
Pentel Pocket Brush
PITT India Ink brush pen
pointed (dip) pen nib NIKKO G

Household/Office and Hardware Tools

alphabet stencils
alphabet stickers
baby wipes
ballpoint pen
computer/inkjet paper
cotton swabs (or dual-tipped cotton swab applicators)
crayon (white)
credit card/hotel key (old)
deli paper (lightly waxed)
letterpress blocks
makeup wedges (disposable foam)

manila file folders
manila tags
nail polish remover
painter's tape
paper plates
paper towels
sandpaper (heavy grit, medium, fine)
Sharpies
spreaders
tissue paper
toothpicks, bamboo skewers
tweezers
typewriter

Surfaces and Substrates

140 lb. watercolor paper (hot press), 9" x 12" or larger
canvas or wood panels (any size)

Found and Made Letters

computer printed font alphabets in different sizes
found papers with different sized words, phrases (pages from magazines, catalogs, junk mail, etc.)
old novel, dictionary, newsprint, etc.



Applied Lettering

Working as a professional calligrapher with a background in graphic design, I am, you can imagine, a huge fan of lettering in all its forms. A majority of my art contains lettering that is either applied as calligraphy, collaged, or stamped. Applied lettering, for the purposes of this book, is anything that is applied to the top of my art. Whether it's found lettering from magazines or something that I handmade like a computer-printed font that I "adjusted" by copying larger and larger to create a deteriorated look—I just love adding some form of lettering to artwork to create the perfect message. I think there is such a great creative potential in using lettering that is found, collaged, traced, copied, stamped, stenciled, or typed—whatever way you can get lettering into your art, do it.

Working with applied lettering in various forms allows the artist a flexibility that handwriting directly on your artwork does not. You can move lettering around and see what the whole design will look like, and when you like the layout, you can then collage the lettering to your surface. Making your own prints from block or gel plates is really fun too. You might create art directly or create lettering that you can then collage onto a larger piece.

Applied lettering can also be layered to create some lovely effects; whether you want your final piece to still be "readable" is up to you. I think some of the most interesting mixed media art are pieces that have areas that are almost unreadable, creating a visual "texture" that ironically often comes from using text. Let's get started and you will find a variety of ways to use applied lettering . . . and maybe come up with some of own your interesting variations too. As you explore, remember that there are really no mistakes, except perhaps gluing something to your table or floor! The advantages of working with lettering with paint make for endless variations and also allow you ways to "fix" things and paint over things. Embrace the fun of working with applied lettering and allow yourself to play.

Letter Love. **Techniques used: gel plate printing with fluid acrylics and craft foam letters onto watercolor paper with added color washes.**

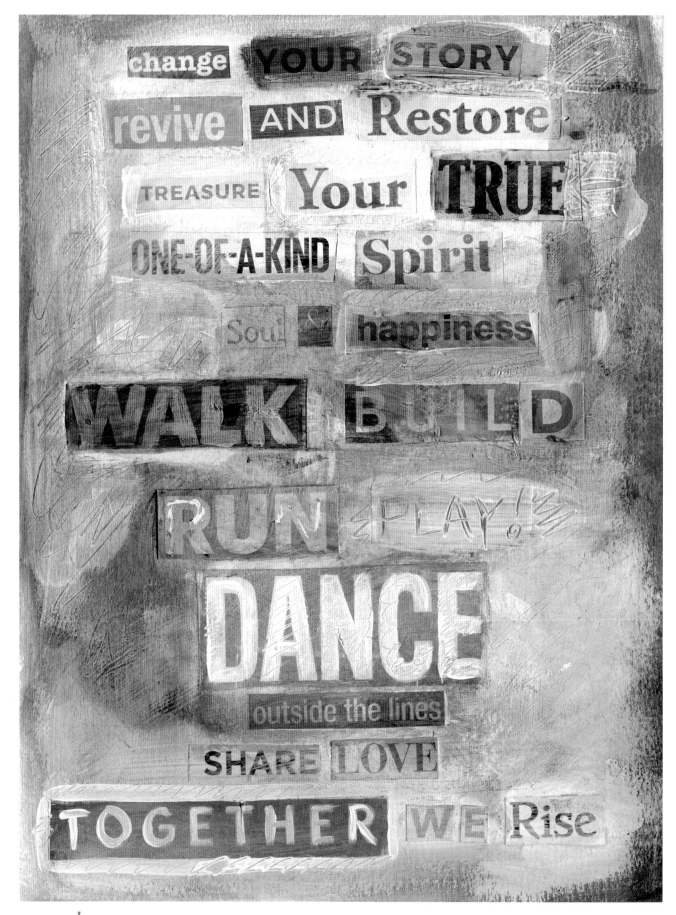

Together We Rise. **Techniques used: found text collage with acrylic soft gel, gesso washes with scribing, acrylic color washes.**

COLLAGED

Found Type Collage

Let's start with basic collage with lettering. You'll learn basic skills that will apply to all collage techniques in this book. Think about the childlike "ransom note" style of collage where you cut and paste letters in different fonts and colors from magazines, old books, newspapers, and even junk mail from your recycle bin. But instead of cutting and pasting with a glue stick, let's take it one step further artistically and make it more integrated and interesting, using acrylic soft gel, gesso, and paint.

Start with a gesso-primed surface—cardboard, mat board, canvas, wood, or watercolor paper will work just fine. You can also have the background already painted a color if you want. I started with a plain white, gesso-primed sheet of watercolor paper. Often I will almost finish an entire piece of art, leaving room for lettering as the final element, but you can work in a number of ways, starting with lettering, layering lettering in the middle, or as a final element. Just be careful if you start with lettering—not to let it get too buried under paint and collage items, unless that is the look you are going for.

Embrace the idea that there is no such thing as a mistake. We all are explorers, and sometimes what you think is a mistake becomes a wonderful discovery of some new technique. So don't waste time chastising yourself for screwing up.

We'll use the basic collage technique with acrylic soft gel for all the projects in this book that require collage. You can use matte finish, semigloss, or gloss. I prefer matte; it's easier to work with other mediums like pencil and ink over the top since it is less glossy. You can always finish your piece with a gloss varnish if you like a shiny final surface. We'll also be adding a gesso wash and washes to make the letters our own and avoid the full ransom-note feel. Remember that gesso is a relatively opaque medium. If you don't add a little water to it, it will almost completely cover whatever is underneath it, and it does not dry less opaque; what you see is what you will get, so plan accordingly. You can cut out the letters you will be using with scissors or tear them carefully to have a ragged edge instead of a straight edge, which ends up softer and more flush to the surface.

If you are using a wood panel, start with one coat of gesso and let it dry. The water content in the gesso will raise the grain of the wood and make it

Materials Needed

- found text from magazines, old books, dictionaries, junk mail, etc.

- 9" x 12" sheet of hot press watercolor paper, canvas, or wood panel

- acrylic soft gel matte

- white gesso

- 2–3 colors acrylic paints (heavy body or fluid)

- ½" and 1" flat brushes

- water container

- paper towels

- baby wipes

- spreader, plain wedge, or old credit cards/hotel key

Optional:

- toothpick or other tools for mark making

- sandpaper

- scissors or X-Acto knife

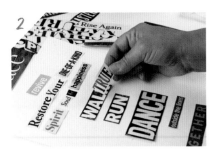

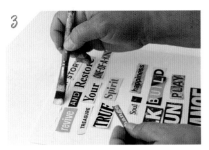

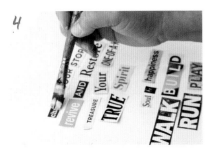

1 Cut or tear your letters from magazines, newspapers, old novels, junk mail, etc.

2 Create a pleasing layout, finding the right balance between size and shape. Don't worry too much about color, since you will be adding paint to later stages of this project.

3 Apply acrylic soft gel; brush into an area slightly larger than the piece you are gluing down.

4 Place the paper you are collaging down into the soft gel. Brush gel over the top, smoothing out any wrinkles. Continue with all letters or phrases. Let dry.

rougher. Use a heavy grit sandpaper and sand in the direction of the grain of the wood. You can choose to apply another coat of white gesso and let it dry, then sand again with a medium or lighter weight of sandpaper. Typically, I do only one coat of gesso on wood panels, since there will be many layers of paint or collaged items over the top. When I have finished a wood panel, I will prime the back of the wood panel with black gesso, let it dry, and then seal with a water-based varnish like DuraClear.

When working on watercolor paper with acrylics, I also like to do a coat of gesso. If we start with a gesso-sealed surface, any mistakes that you make with stamping and printing can be pulled off with a baby wipe before it dries. I also like to apply a gesso on watercolor paper in a dry brushed method. When dry brushing with gesso, use gesso straight from the container, with no added water. If your brush was sitting in water, wipe it dry on a paper towel before dipping into your gesso. Brush quickly in random directions when applying, leaving gaps and allowing the white paper to show through. Once dry, this gesso protects parts of the paper beneath it from full absorption of paint. It automatically creates a variegated surface that is really beautiful even if you are adding only one wash of color.

In Focus: Gesso 101

Most of the projects in this book start with gesso. Gesso (pronounced "jesō") is similar to acrylic paint, but it is usually thinner and dries to a harder, slightly textured surface that accepts paint colors nicely. It is made of acrylic polymer, calcium carbonate (which provides a chalk-like ground), and white pigment such as titanium dioxide. Gesso helps prepare almost any surface for paint as a primer, creating a nice white base for paint colors to be true and vibrant. Different brands of gesso might be thicker or runnier. As you get more experienced using gesso, you will discover which brands are your favorite for certain techniques. I find that thicker gesso is nice for covering over an area you want to hide, or to use for stenciling and any technique where you want to make marks into the surface. Thinner gesso is better for layering over collaged items to create a surface for your next layer of color. In this book we will also be using a gesso wash, which is gesso with a touch of water to thin it; you can also alternatively use a more watery brand of gesso. Gesso also comes in clear, black, and some colors. White is the traditional color that you will find yourself turning to most often. You can even use white gesso to mix with your paint colors to lighten or tint them instead of using white paint. We will also use black gesso, which has a nice opacity and is useful for covering any areas you don't like, as well as creating a lovely base coat for a different effect. I even recommend using black gesso instead of black acrylic paint.

In Focus: Gesso Wash

A gesso wash is gesso with a little bit of water added. You don't have to mix this up in a special container or anything; just make sure your brush has a little water on it before you dip into gesso and apply. The goal is to make the gesso less opaque when painting over a collaged item, as well as laying down a white base to pick up paint color in the next step. Have a dry cloth or paper towel handy to dab off excess water if necessary.

Handy Tip: Smoothing Wrinkles

To smooth out paper when you are collaging with matte medium or soft gel, you can use your paintbrush. But sometimes you need something a little stronger to smooth out a bubble or crease. You can use an old credit card or hotel key, but I prefer to use an artist wedge or a hardware store spreader. I like the plastic spreaders since they are not as expensive as wedges. They are usually found in the varnish section of the hardware store. Just be careful that you are not scraping too hard and tearing the paper.

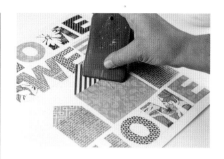

Smooth out any air bubbles or wrinkles, using a wedge or spreader tool.

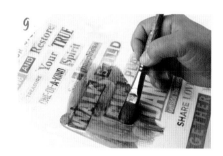

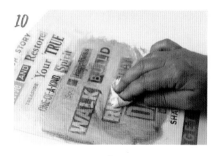

5 When your collage is completely dry, brush a gesso wash over and around the edges of your letters. This is called a gesso wash. Work step-by-step in a small area so that the gesso wash does not dry too quickly.

6 Use a dry paper towel or a cloth rag to dab or wipe off excess gesso in any areas that you have applied the gesso too heavily and can't see your letters.

7 *Optional:* While the gesso wash is still wet, you can add some mark making—scribing or sgraffito texture (see page 105) with a toothpick or the tip of your brush. Let dry.

8 Add a light color wash (acrylic paint with a little water or matte medium). Use a paper towel or soft cloth to buff or move the paint around to remove any paint in areas where you applied it too thick.

9 Continue to add thin color washes. If the first color is still wet it will blend together, or you can wait until one color is dry to add others so they don't mix.

10 Continue to move the paint around or off the surface with a paper towel, blending and removing brush marks if you like.

11 Use a baby wipe or damp paper towel to remove color from an area that might have too much paint covering your collaged items before it dries.

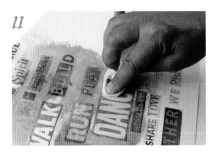

12 Continue with another color as desired.

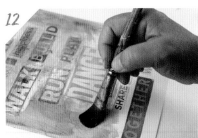

13 Add another color wash as desired.

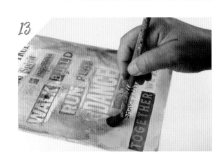

14 Continue with layering. Try some scribing with a toothpick or X-Acto tip into any wet areas of gesso wash or wet color wash.

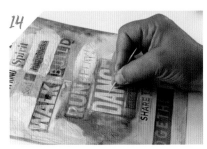

15 Add gesso with a tiny brush to augment lettering that has become obscured or that you want to highlight.

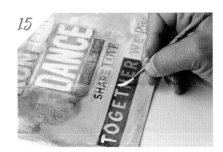

16 Use gesso or gesso wash to lighten an area and optionally add more texture with a toothpick. Let dry.

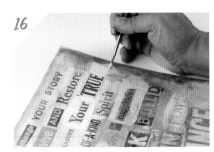

17 Add more color washes and buff with paper towel.

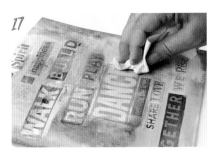

18 Add more gesso to areas you want to lighten and scribe into it if you like.

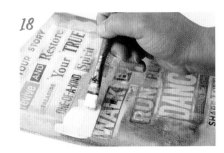

19 Add more color wash as you see fit.

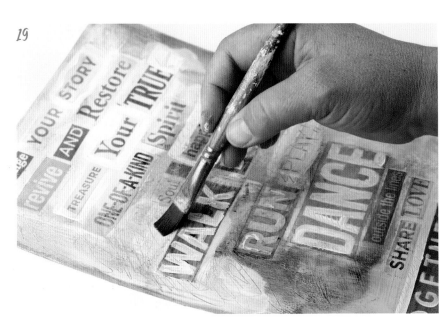

Variation: Painted Background Collage

You can also choose to start with a painted background before you collage. In this variation I painted some colorful stripes in acrylic paint over a gesso-primed surface, let dry, then sanded it slightly with heavy grit sandpaper to make an interesting texture with light scratch marks. Then I sanded with a medium or lighter grade sandpaper to create a smooth surface for the collage pieces to adhere to.

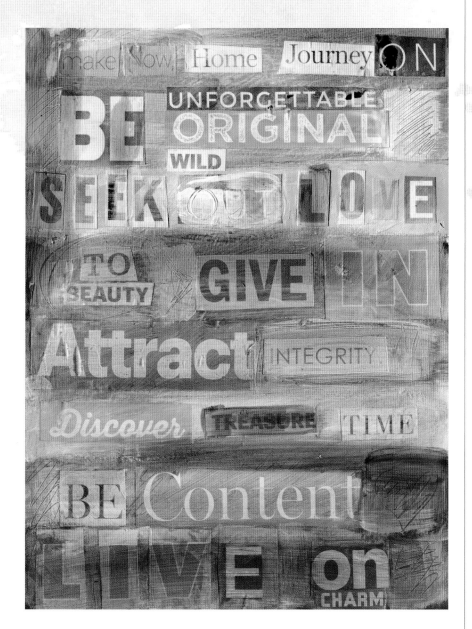

Seek Out Love. Techniques used: found paper collage with acrylic soft gel, gesso washes with scribing, color washes on watercolor paper.

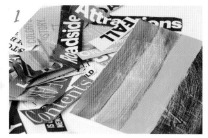

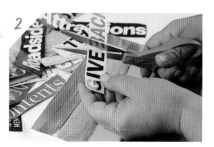

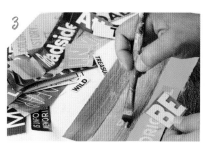

1 Start with a painted substrate that is dry.

2 Cut or tear the lettering you want to collage.

3 Paint acrylic soft gel matte in a small area slightly larger than the word you will be placing.

4 Place your word. Paint over it with soft gel. Continue in the same manner as the steps on the previous section, adding layers of gesso wash and color washes as you like.

In Focus: Color Wash

A color wash, also called a paint wash, is a simple way to add a thin, transparent layer of color. Dip your brush in water before you add paint to your brush. I love adding a color wash over a gesso wash after it has dried. I use color washes to add warmth to an area with a light color like Quinacridone Nickel Azo Gold, to add color to a collaged item, or to add an antique look like color washing with a Burnt Umber or other dark color. I also recommend having a cloth or paper towel available to buff, or move the paint wash around without leaving brushstrokes.

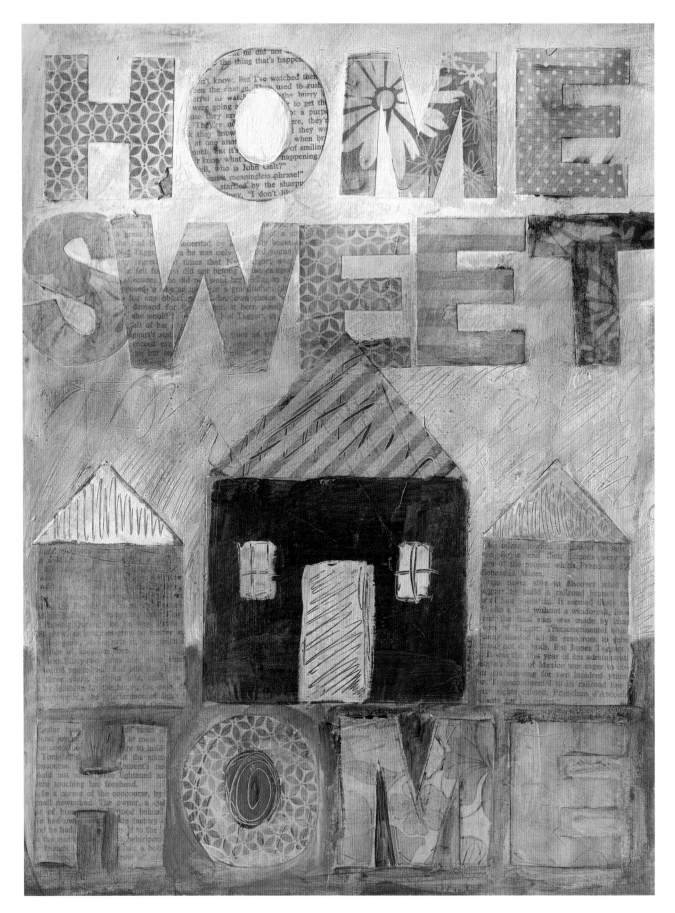

Home Sweet Home. **Techniques used: decorative paper collaged with acrylic soft gel, gesso and acrylic paint scribing, and color washes.**

Decorative Paper Letters

Sometimes the beauty of collage depends on what decorative papers you use, whether they are commercially produced, hand painted, or stamped by hand. I like to use a mix of decorative, handmade, and old novel newsprint. For this style of collage I would recommend using larger letter designs so they will be easier to cut with scissors or an X-Acto. You can trace letters from magazines or books, but in order to have the full alphabet available I usually type alphabet letters on my computer in a word program. Using the outline setting on your font helps keep from wasting printer ink. Most word programs will allow you to create larger than 72 point letters; just type a larger size into the box, such as 150, and hit the return button to activate the new type size. Once you cut out and collage down your letters, you can leave the letters like that or do the optional overpainting with gesso wash and color washes to really make the designs your own.

Materials Needed

- decorative or hand painted papers, old novel newsprint
- 9" x 12" sheet of watercolor paper, canvas, or wood panel
- acrylic soft gel
- white gesso
- 2–3 colors of acrylic paints (heavy body or fluid)
- ½", 1" flat brushes, small pointed brushes for details
- ballpoint pen
- ruler
- Saral graphite transfer paper
- tracing paper
- large letters for tracing
- scissors
- water container
- paper towels
- baby wipes
- spreader, plain wedge, or old credit cards/hotel key

Optional:

- toothpick or other tool for mark making, sandpaper (assorted weights)
- X-Acto knife
- cutting mat

1 On tracing paper, draw your words or trace from a computer font. Use larger letters, such as 2-inch-tall capitals.

2 Place graphite transfer paper dark side down on top of decorative paper and retrace your word design with a ballpoint pen, pressing hard enough to transfer graphite to decorative paper, use a ruler if you like.

3 Without shifting your design, carefully lift up transfer paper to check to make sure you are pressing hard enough to transfer your design. Finish tracing your design or touch up any lines that you missed.

4 Cut out the letter with scissors or an X-Acto knife.

5 Continue with other letters and other decorative papers.

6 To cut round shapes, use scissors or a swivel X-Acto knife.

7

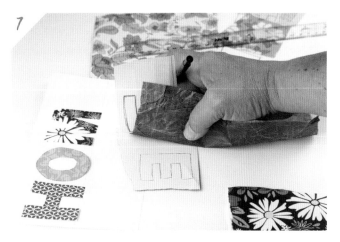

10

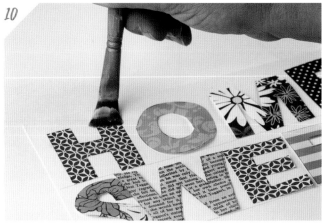

8

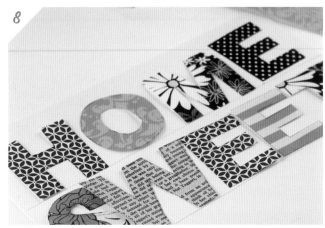

11

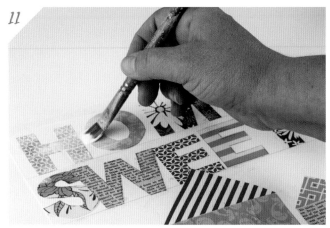

9

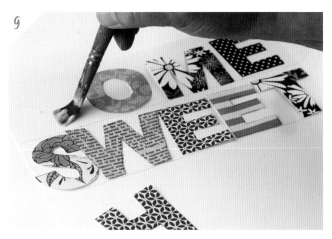

12

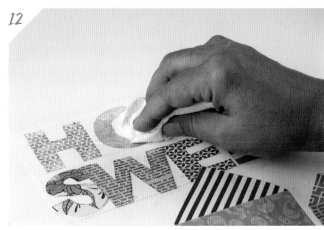

7 For complex or dark patterned decorative paper, flip the paper upside down so the white back is showing, flip your traced design so it reads backward and retrace the letter to transfer your lines.

8 Continue with the rest of your letters and any other design elements.

9 Apply acrylic soft gel in small areas slightly larger than the element or letter you are gluing down.

10 Brush gel over the top of the letter, too. Continue with the rest of your letters or other elements. Let dry.

11 Add gesso wash in a thin layer over the lettering.

12 Buff and wipe off any excess gesso with a paper towel. Let dry.

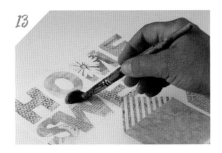

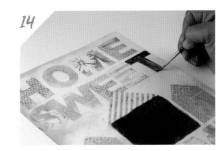

13 Add one or more color washes, buffing to remove brush marks and move the paint around.

14 Use smaller brushes to add details with color if needed.

Optional: Sanding Back

Whether you are working on a collage with paint or just a painted surface, sanding back is an excellent opportunity to create some interesting texture. Sometimes your goal is to remove just touches here and there that will lighten and lift the paint. Sometimes I use sanding to smooth out the brushstrokes so that I can do rubber stamping or writing over a smoother surface. For texture, I would recommend sanding in many different directions. For smoothing the surface, go in the direction of the grain of wood, or go in one direction, left and right along the writing surface. After sanding you can also apply a light wash of color.

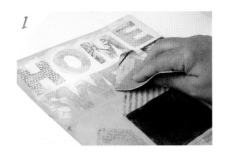

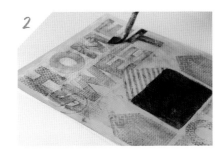

1 Use medium or heavy grit sandpaper to sand in various directions (called sanding back) to create texture and remove peaks or high points of your collage.

2 Add a color wash. Color will seep into areas that you sanded back.

Optional: Adding Texture in Wet Gesso

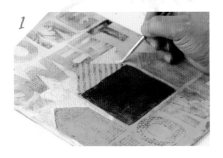

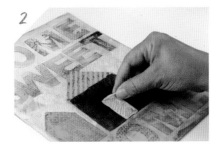

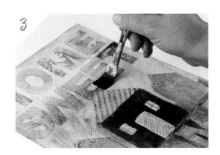

1 Optional: Add more gesso to lighten areas to reveal your text.

2 Add optional scribing lettering or pattern with toothpick or other tool. Let dry.

3 Optional: add more color washes as desired.

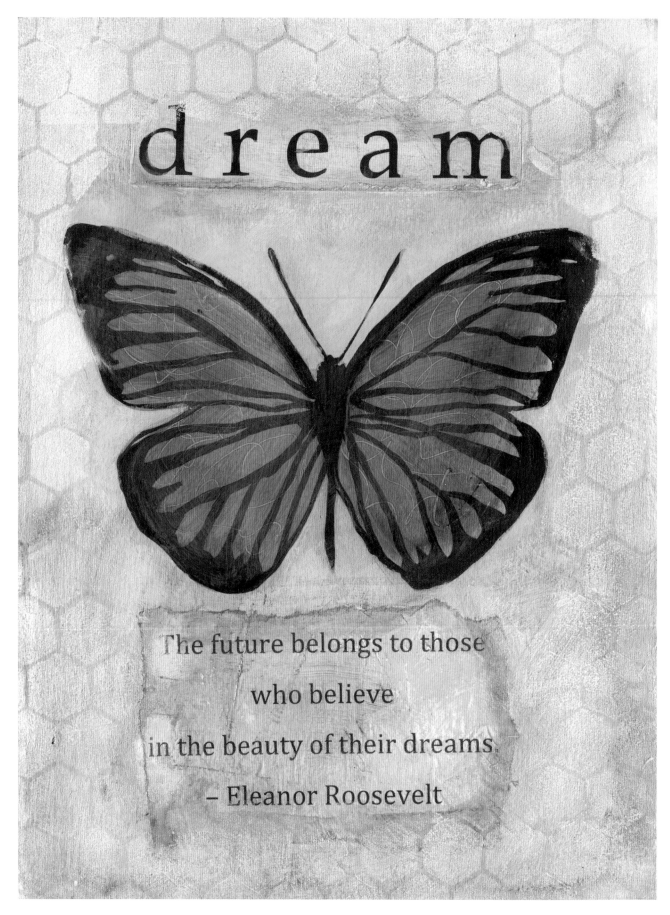

Butterfly Dream. Techniques used: collaged copied text with
acrylic soft gel, acrylic paint, stenciled pattern in gesso with
a color wash.

Computer Printed or Copied Lettering Collage

Working with computer printed or copied lettering gives you some added flexibility since you can write your own words, space out your letters, and choose your favorite fonts. Depending on how skilled you are at using various computer programs, you can prepare your lettering line by line before printing. I like being able to change the size of text and redo things easily with this method, but you are stuck with whatever paper goes through your printer or copier machine. Some machines can be cajoled into taking watercolor paper, but typically I would just print out my lettering on regular inkjet paper and then collage it onto my substrate.

Inkjet printouts will work, but be aware that there is a slight bleeding that can occur when you brush acrylic gel over inkjet, especially with bolder and colored letters, so it's best to use black-and-white copies, color copies, or laser prints that are heat-set in the machine. If you are adding a lot of gesso and paint around the letters, it won't make too much of a difference which type of printer you are using. I prefer to work with black text, but if you have a color printer or can get some color laser copies from your local copy store, you can use colored letters and really expand your lettering choices. You can also print onto different colored papers like antique yellow parchment. You can collage paper as is or add a color wash before you collage.

Materials Needed

- printed (copied or laser printed) quotes or large text
- 9" x 12" sheet of watercolor paper, canvas, or wood panel
- acrylic soft gel
- white gesso
- 2–3 colors of acrylic paints (heavy body or fluid)
- ½", 1" flat brushes, small pointed brushes for details
- ruler
- scissors
- water container
- paper towels
- baby wipes
- spreader, plain wedge, or old credit cards/hotel key

Optional:

- toothpick or other tool for mark making
- sandpaper (assorted weights)
- nail polish remover
- heat tool

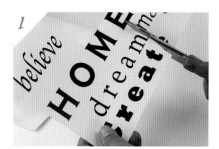

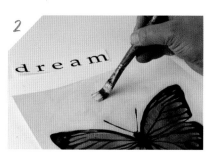

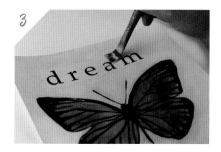

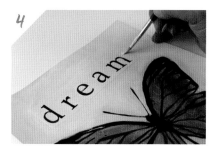

1 **Print out words from your laser printer or copier. Cut or tear edges as desired.**

2 **Apply acrylic soft gel or matte medium to substrate in area a little larger than the word you are adhering.**

3 **Brush gel over the top of the word, smoothing out any wrinkles.**

4 **Optional: Apply gesso, paint, or both over the edges and into the word to incorporate it into your design.**

5 Tear edges of paper you are collaging for a different, softer look.

6 Apply color wash before you collage the paper if desired. Let dry.

7 Brush soft gel or matte medium in an area slightly larger than the item you are collaging.

8 Brush gel over the top and edges of the paper. Let dry.

9 Sand the edges of the collaged paper with medium grit sandpaper to soften them into the background.

10 Use a pattern stencil (see pages 57-58 for stenciling techniques with gesso applied with a makeup wedge) to stencil over the edge of collaged paper with white gesso to help it disappear.

11 Add paint wash to areas you stenciled if desired.

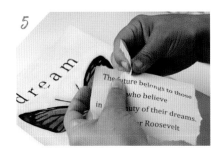

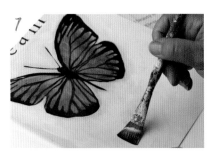

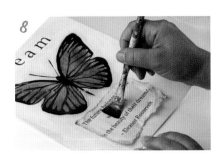

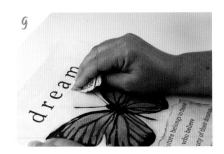

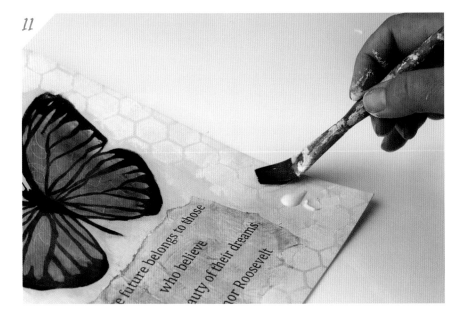

Quick Fix:
Nail Polish Remover

If you overpainted any area and it is too late to use a baby wipe since the paint has dried, you can remove paint using a paper towel dampened with nail polish remover. Use sparingly so as to remove only the top layer; otherwise you will have to touch up with some more paint or re-collage a replacement piece.

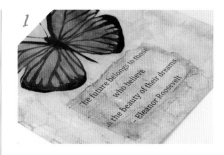

1 Find an area that has been overpainted and is already too dry to wipe off.

2 Use paper towel dampened with nail polish remover to carefully lift off the excess paint but not the text underneath. Touch up with more paint washes if necessary. Or sand and re-collage.

Handy Tip:
Heat Setting Inkjet Prints

In a pinch you can use inkjet prints if you do not have a laser print or copier print to work with. To keep the text from smearing when brushed with gel, dry it first for a minute or two with a heat gun. This will help heat set the pigment.

Heat up your inkjet print with a heat gun for a few minutes, then paint or collage as desired.

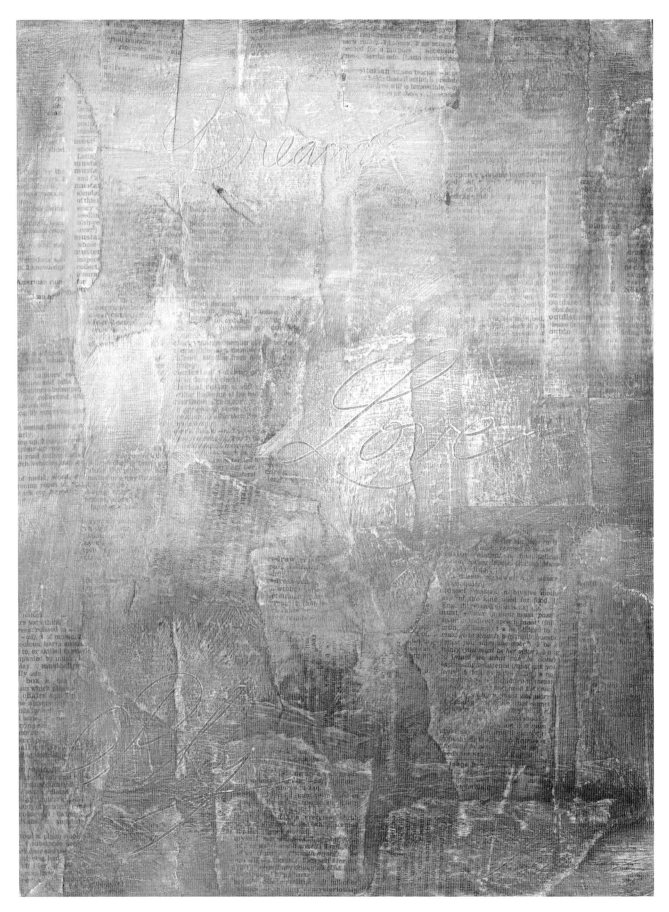

Dream Love Play. **Techniques used: collaged dictionary papers with acrylic soft gel, gesso, acrylic paint, scribing into wet gesso, color glazing on wood panel.**

Background Collage with Found Text

Old novels make great collage material. You can use them in torn pieces and layer them to make a background texture. You can also use a specific block of interesting text or a single line to collage into your piece and highlight it, since sometimes you can find a great sentence or more that can inspire a whole piece. If you find any words or sentences that don't fit the mood of your artwork, paste another torn piece of paper over the top to cover it up, or try turning the paper upside down or sideways. Sometimes it doesn't matter if the subject matter is not related to the artwork that you are creating, especially once you have layer upon layer of beautiful collage, colors, and any other added elements like stencils or stamps.

While you can use acrylic paint directly on top of newsprint, the colors tend to look a bit muddy or dull. I'd suggest using a light gesso wash (gesso with a little water) over novel text after it's been collaged and the soft gel is fully dry. Have a paper towel or cloth handy to wipe off any excess gesso if you apply it too thick and you can't see your text anymore. White gesso dries fairly opaque, so you'll want to use a gesso wash, unless there is a portion of the collaged text that you *do* want to obscure. You can layer the gesso heavier in those areas by using the gesso directly from the container, without any added water.

You can also add some "texture" in a different manner. While the gesso or paint is still wet, scribe into it (also called sgraffito or mark making) with a toothpick or other tool. You can just do scribbles or you can add words; the result is very subtle, depending on how thick your gesso is, but extremely pretty.

Materials Needed

- decorative or handpainted papers, old novel or dictionary newsprint
- 9" x 12" sheet of watercolor paper, canvas, or wood panel
- acrylic soft gel or matte medium
- white gesso
- 2–3 colors of acrylic paints (heavy body or fluid)
- ½" and 1" flat brushes
- scissors
- water container
- paper towels
- baby wipes
- spreader, plain wedge, or old credit cards/hotel key

Optional:

- foreign language novel newsprint
- toothpick or other tool for mark making
- sandpaper (assorted weights)
- acrylic glazing liquid
- black gesso

1 Sand with heavy grit sandpaper in the direction of the grain. If desired you can sand with a medium grit sandpaper afterward. Soften corners and edges if you are working on a wood panel. Optional: Add a second coat of gesso and sand again.

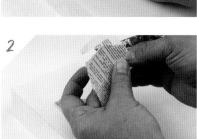

2 Select your newsprint, then cut or tear edges.

3 Brush acrylic soft gel in area slightly larger than the paper you are gluing down.

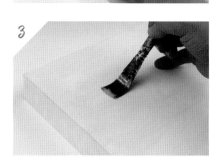

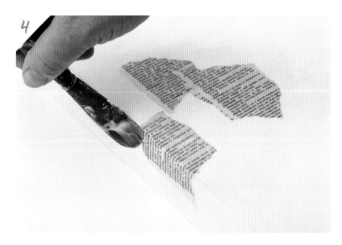

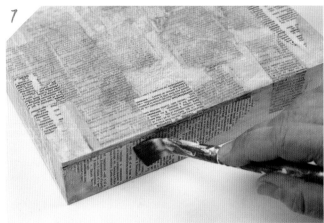

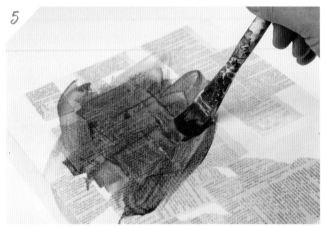

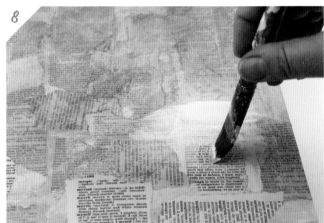

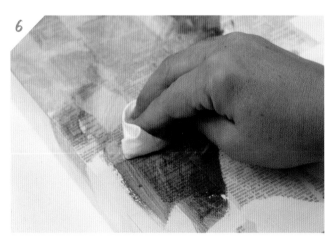

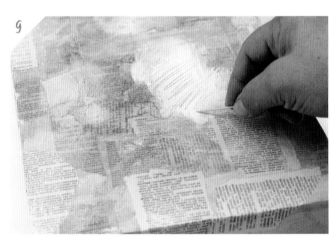

4 Work in small sections. Put your selected paper down into the areas where you brushed gel, then brush gel over the top. Collage over the sides of your piece if you are using a canvas or wood panel. Continue to collage pieces, layering some over the top of others; try some sideways too. Let dry.

5 Apply thin color washes.

6 Buff color wash with paper towel; lighten color in areas you want to, while leaving it darker in other areas. Let dry.

7 Apply more layers of collage if desired. Let dry.

8 Add more gesso wash.

9 Scribe lettering or scribbles with toothpick or other tool in wet gesso. Let dry.

10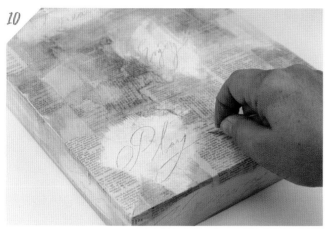

13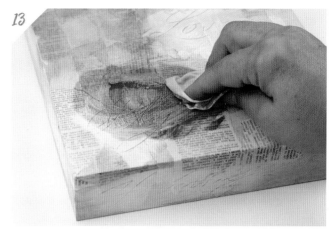

11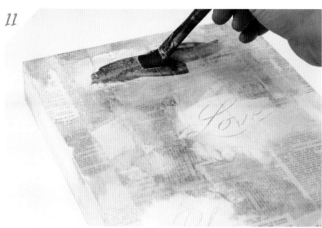

14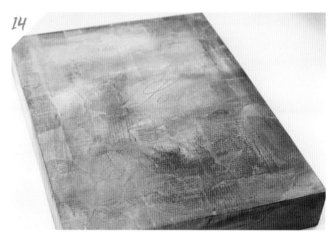

12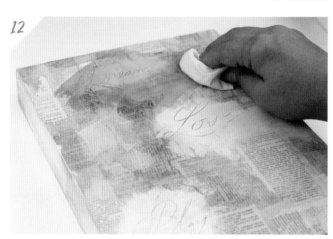

15

10 Scribble words if you like in wet gesso with a toothpick or the tip of a paintbrush or other tool. Let dry.

11 Apply a color wash.

12 Move color wash around with damp paper towel.

13 Apply other color washes.

14 Continue until you have added some paint color to your entire surface. Remember to add color to the sides, too, if you are working on a cradled wood panel or stretched canvas.

15 Optional: Sanding with medium or heavy grit to create an interesting antique effect.

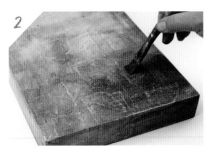

1 Apply a dime to quarter sized amount of acrylic glazing liquid directly to the surface and a few drops of fluid paint or a touch of heavy body acrylic and mix together over the surface. Continue over the rest of the piece. Let dry.

2 Optional: Apply other layers of glazes to create more depth and luminosity.

Techniques used: black gesso with old dictionary newsprint collage with acrylic soft gel, gesso washes with scribing, color washes.

Optional: Matte Medium and Acrylic Glazing Liquid

While color washes make a lovely layer, particularly when you are working over soft gel or acrylic paint, the gel repels the water a little bit, causing it to bead up. When you use matte medium on your brush instead of water; it spreads the paint smoothly without bubbles and helps it adhere to your surface. Matte medium can also be used in lieu of acrylic soft gel to collage.

Acrylic glazing liquid works in the same manner as far as allowing the paint to stick to the surface better without bubbles, but it works in a similar manner to the linseed oil that oil painters use to create super sheer layers that are either glossy or matte depending what type of glazing liquid you are using. It takes a little longer to dry, but you can create some amazing, glowing depth by layering with acrylic glazing liquid.

Variation: Black Gesso Background

Try mixing things up a little. Instead of working with a white surface or substrate, prime your surface with black gesso first and allow it to dry. Sand the surface lightly with medium weight or fine grit sandpaper to make it smooth before you continue with collage. This makes a great start for a black-and-white themed piece, but also works with added color too. Play around with amounts of white gesso, as well as sanding back—sanding with medium to rough grit sandpaper allows the peak of your artwork to wear down and look antiqued. You can then add another light or dark color wash that will seep into the cracks and white spaces for a unique look.

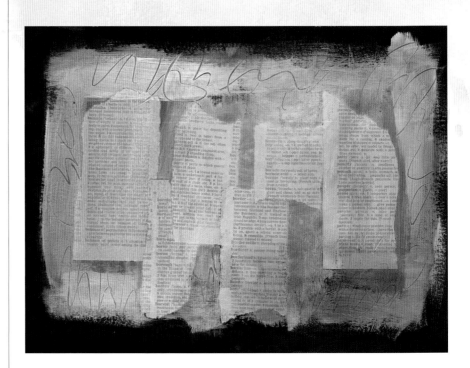

Optional: Foreign Press

Foreign language newspapers, magazines, and even old books can be used for collage, making your piece a bit more exotic and sometimes the perfect background for a particular project. Just be careful that you aren't using a serious article about modern government or politics for that image of a heart or puppy or whatever. Check with someone who speaks the language or search for translation of the text you're using online.

Techniques used: old foreign newsprint collage, decorative paper collage, gesso wash, acrylic paint washes.

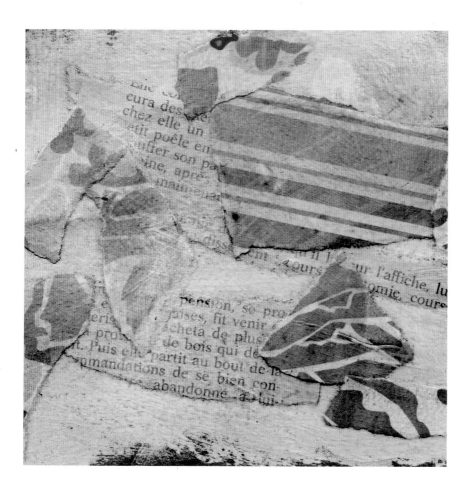

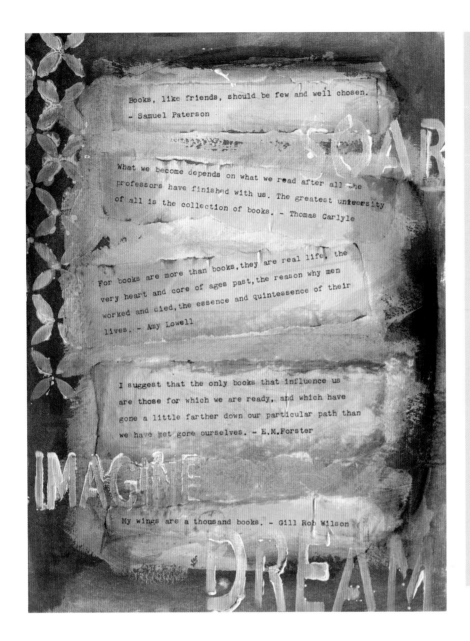

Materials Needed

- typewritten text on your choice of paper

- 9" x 12" sheet of watercolor paper, canvas or wood panel

- acrylic soft gel

- white gesso

- 2–3 colors of acrylic paints (heavy body or fluid)

- ½" and 1" flat brushes

- scissors

- water container

- paper towels

- baby wipes

- spreader, plain wedge, or old credit cards/hotel key

Optional:

- toothpick or other tool for mark making, sandpaper (assorted weights)

- stencils (word and pattern)

Typewritten Letters Collage

Whether you have an electric typewriter—or, better yet, a vintage manual typewriter—you can write your own wording and give your project a nostalgic touch. The spacing and irregularities—even typos, if you make them—are spectacular. Use whatever paper you have that fits in your typewriter, but typically I just use inkjet paper as it is thin and easy to collage. If you use a typewriter font on the computer, you won't get quite the same effect; it will be a little too perfect. But you can use a copy machine to xerox and enlarge and make a copy of a copy until your font degrades. Remember you can also use typewritten text as a background, like we did in the last section.

More Than Books. **Techniques used: typed text on parchment collaged with acrylic soft gel, paint washes, brushed gesso stenciling on watercolor paper.**

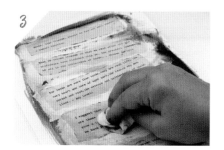

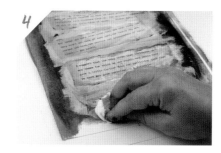

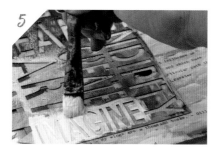

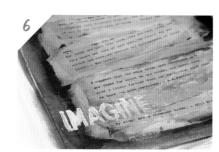

1 Start with unprimed watercolor paper or primed wood or canvas. Apply gel to your surface, slightly larger than the piece you will be gluing down.

2 Place your paper and brush gel over the top of the piece. Continue in the same manner with all papers to collage. Let dry.

3 Apply paint wash. Paint will appear darker in areas without gel.

4 Buff paint wash; add second color paint wash. Let dry.

5 Optional: Apply gesso through stencil with brush for an imperfect stencil. (For more details on stenciling see pages 57-58.)

6 Let stencil dry. Add color wash if desired.

Quick Fix

If you notice a typo or some error as you are gluing down a piece of collage paper, before it sets, you can scrape or peel it back off the surface. Use a little water or baby wipe if necessary. If the paper has already dried, you can sand it off and paint over it.

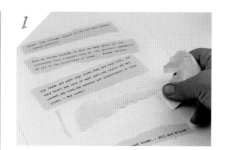

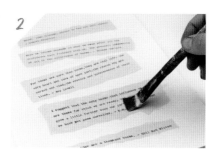

1 Before it is dry, peel off the paper you have collaged that has a typo. Use a scraper if necessary. Let dry. Sand surface if too much of the paper is still stuck to the surface.

2 Apply replacement collage piece.

LET US BE

GRATEFUL TO

PEOPLE WHO MAKE

US HAPPY,

THEY ARE THE

CHARMING GARDENERS

WHO MAKE OUR

SOULS

BLOSSOM.

-PROUST

Charming Gardeners. **Techniques used: painted acrylic background on watercolor paper (sanded smooth), stamped StazOn black lettering, PITT pen details.**

STAMPED

Rubber Stamped Lettering with Stamp Pads

Rubber stamped lettering is a nice way to finish a piece of art, as a final touch. There is a plethora of wonderful commercially-made stamps with single words or phrases or individual alphabet letters. I like using individual alphabet letters so I can construct my own phrases or just use them for decoration for an alphabet-themed piece of art. It's important to use solvent-based permanent ink stamps since both pigment stamp pad ink and dye-based stamp pads are not waterproof and will blur if you stamp letters and then do any additional collage with soft gel or if you want to paint over the lettering. I recommend StazOn permanent ink pads, but there are several other brands that offer archival, permanent inks. They make special stamp pad cleaners, too.

	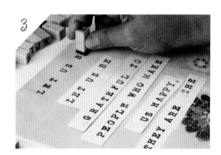
	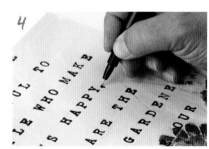

1 Start with a painted acrylic background or design. Add guidelines if desired (see Handy Tip: Disappearing Guidelines, p. 38).

2 Gather your alphabet stamps and permanent stamp pad.

3 Practice stamping your phrases on scrap paper first. Then stamp onto your surface, letter by letter, word by word.

4 Add punctuation that you don't have a stamp for with a PITT pen or other permanent pen that matches the color of your stamping. Let dry.

Materials Needed

- 9" x 12" sheet of watercolor paper, canvas, or wood panel
- white gesso
- 2-3 colors of acrylic paints (heavy body or fluid)
- 1" flat brush
- ruler
- white water-soluble pencil (Caran D'Ache)
- water container
- paper towels
- baby wipes
- alphabet stamps
- permanent stamp pad (StazOn or other waterproof)
- StazOn or other permanent stamp pad cleaner

Optional for variations:

- manila tags
- tissue paper
- embossing powder
- heat tool
- embossing stamp pad
- PITT or Micron pen

1 Draw guidelines using a ruler or triangle and water-soluble pencil like a Caran d'Ache. Use white for a darker surface or light blue for a light or white colored surface.

2 After your stamping is fully dry, wipe off your guidelines with a damp cloth.

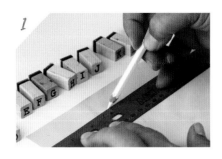

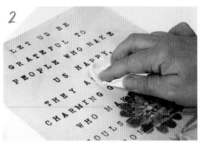

Handy Tip: Disappearing Guidelines

If you want to have a ruled line to line up your letters on your art, try using a Caran d'Ache water-soluble pencil. Graphite pencil is hard to fully erase when working with acrylic, stamped and collaged art. I discovered that a white watercolor pencil like a Caran d'Ache will show up nicely on dark art and is completely removable without disturbing any or the art. That is one of the best reasons to always use permanent stamps, pens, and paints. After your permanent stamping has dried you can erase the Caran d'Ache guidelines with a slightly damp paper towel.

1 Find any stamped letters that are not perfect or are a little faded.

2 Touch up the misprinted letters with a PITT pen or other permanent ink pen to fill in the black. Use your practice stamp sheet for reference if necessary.

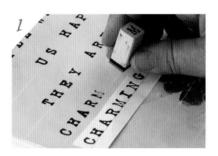

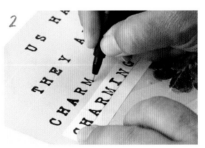

Quick Fix: Bad Stamp Touch-Up

If you find that you have understamped a letter with StazOn and it appears light or not full, use a PITT, Micron or other permanent pen to fill in the letter and darken it.

Variation: Rubber Stamped Letters on Tags

For this technique you can use manila tags or any other loose paper; it can be painted already. One advantage with stamping onto paper that you collage rather than stamping directly onto your artwork is that you have some flexibility; if your stamp does not work well, you can grab another tag or sheet of paper. You can also space out the letters in a different manner before you collage. You can also cut the letters out and collage them separately. Always stamp letters using permanent stamp pads onto paper or manila tags, just in case you decide to collage the tag and need to brush over the top with soft gel or paint.

Techniques used: StazOn rubber stamped letters, embossed letters, acrylic paint, gesso deboss with plastic embossing folder, gesso stenciling, color washes on manila tags

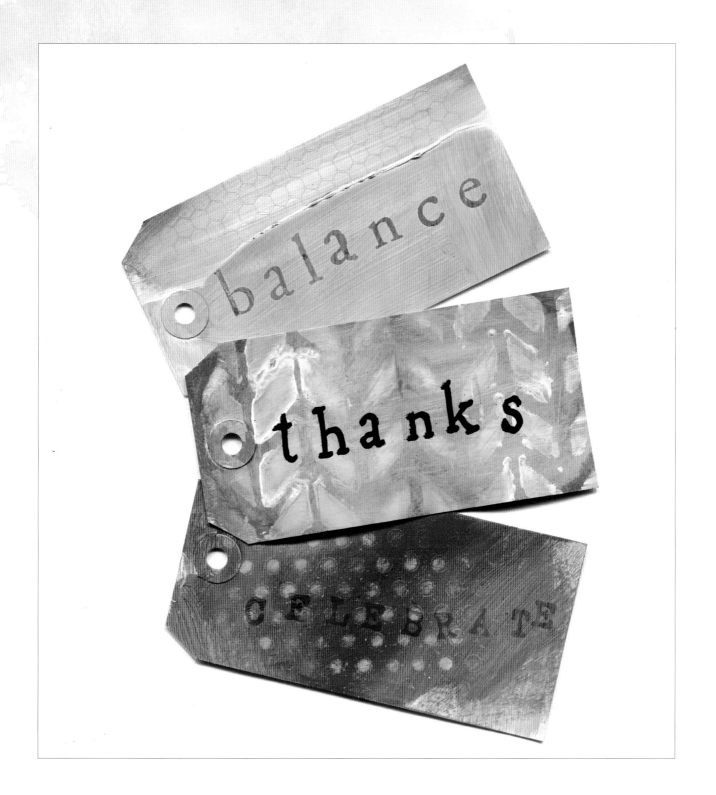

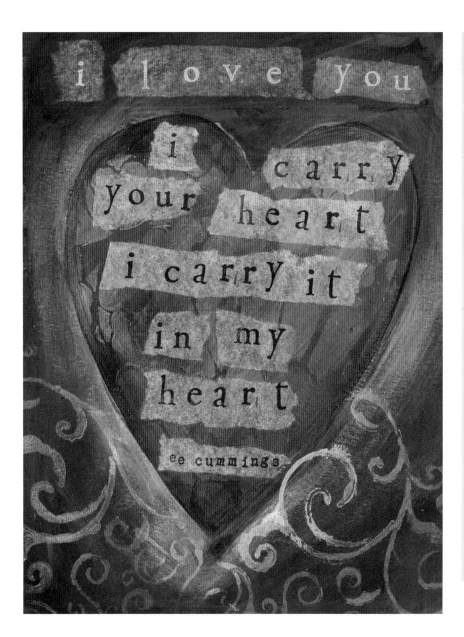

Materials Needed

- painted artwork
- tissue paper
- acrylic soft gel or matte medium
- 1/2" flat brush
- water container
- paper towels
- baby wipes
- alphabet rubber stamps
- permanent stamp pad (StazOn or other waterproof)
- StazOn or other permanent stamp pad cleaner

Optional for variations:

- embossing powder
- heat tool
- embossing stamp pad
- tweezers or metal palette knife

Rubber Stamped Letters on Tissue Paper

Working with rubber stamps directly on artwork can be a bit daunting, especially since you are working with permanent stamp pad inks. It's sometimes hard to line up your stamp, or you have spacing issues and run out of room. Usually these little "mistakes" are just wonderful and whimsical, but if you want a little more control of your stamped letters, try using tissue paper. You can stamp with your permanent colors or black ink pad on a sheet of regular gift wrap tissue paper; I like to use small pieces with torn edges. You can use a piece that is the length of the area you want to collage, or you can letter individual pieces and space them out. I usually start with a piece the length I need and then tear it apart if the spacing isn't to my liking. The nice thing about the tissue paper is that is has a tendency to become a little bit translucent, particularly over white or light-colored backgrounds.

i carry your heart. Techniques used: acrylic paint, gesso stenciling, StazOn stamped tissue paper, embossed tissue paper, color washes on watercolor paper.

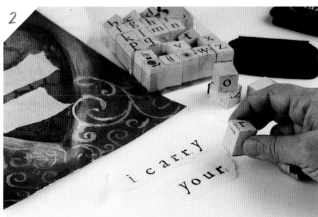

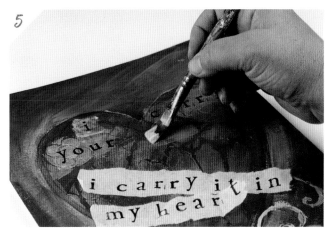

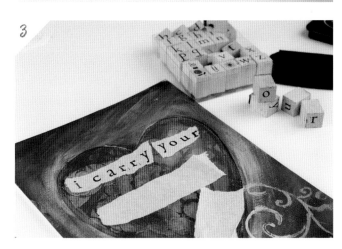

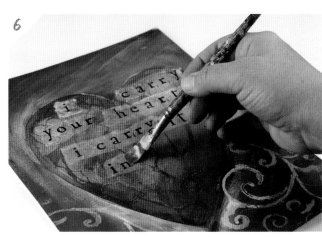

1 Start with a painted background or design. Tear tissue paper into long strips. Use pieces longer than you think you will need; you can always tear them shorter later.

2 Move your tissue onto a scrap paper or protected table surface. Stamp your letters.

3 Test your layout for spacing and line-by-line breaks.

4 Lay out all your stamped words to make sure they fit.

5 Paint gel in a space a little larger than the tissue you will be collaging.

6 Place your tissue and brush gel carefully over the top. Don't brush too hard or you will tear the tissue. Continue with the rest of your text.

Variation: Rubber Stamp Embossed Text

Rubber stamp embossed lettering is a great way to add lettering that stands out a little more with dimensionality or color. While it does work directly on your artwork, there is a lot of room for error with this technique, so I recommend practicing on paper first or using the embossed lettered paper to collage onto your art. Working on tissue paper will allow you to test to see if you like the look and color. If you like it, you can emboss directly onto your art or just collage the embossed tissue paper.

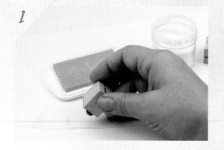

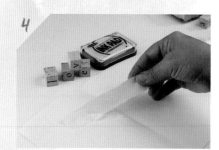

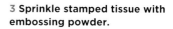

1 Stamp onto tissue paper, using an embossing stamp.

2 Continue with full word or you can emboss as you go.

3 Sprinkle stamped tissue with embossing powder.

4 Tip off extra embossing powder onto scrap paper.

5 Pour excess embossing powder back into original container.

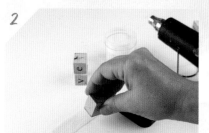

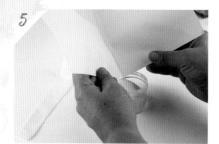

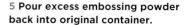

6 Apply heat with heat gun. Do not stay in one place too long. Move tool around about 2–3 inches from surface until all powder has melted. Use metal palette knife or tweezers to hold your tissue paper.

7 Apply soft gel to your art and set down the embossing tissue.

8 Brush gel over the rest of your embossed tissue.

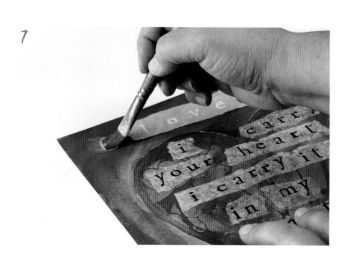

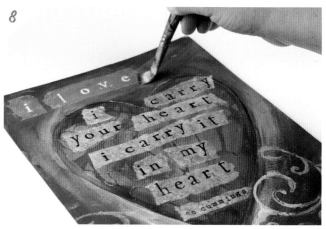

Handy Tip: Embossing Fix

If you overstamp and there is embossing fluid on your surface outside the boundary of your letter, you can try to remove it with a baby wipe before you sprinkle your embossing powder. If you have already sprinkled your powder and you see the error, use a dry brush to wipe off the powder from the area before you hit it with a heat gun. Any stray powder anywhere on your surface with melt and stick when you heat it up, so it is best to blow off (no heat), brush off, or use an X-Acto knife to clean up any errors before using the heat gun.

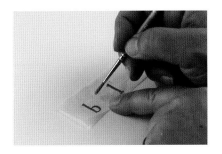

Use a dry paint brush or an X-Acto knife tip to wipe off or gently scrape any embossing powder that is stuck to a place on your tissue that is not a letter (any overstamping).

Variation: Embossed Tissue Paper with Gold Powder

Embossing powder comes in a variety of colors and metallics. Sometimes a metallic gold works perfectly for your project. Working on tissue paper will allow you to test to see if the gold works on your art. If you like it, you can emboss directly onto your art or just collage the embossing tissue paper.

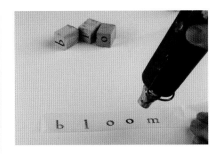

Heat set letters to melt the powder and create the embossed effect. Collage text using acrylic soft gel.

Quick Fix: Removing and Restamping

Small individual letters are not always easy to work with. You may find you have put a letter down in error, or it may be the wrong color of embossing powder and doesn't show up on your art. Before your soft gel dries, pull off the letter with your fingers or a baby wipe and stamp a new letter or letters to replace the error. Flexibility like this is great for creativity.

Scrape off collaged tissue while it's still wet, or use a baby wipe to help wipe it off.

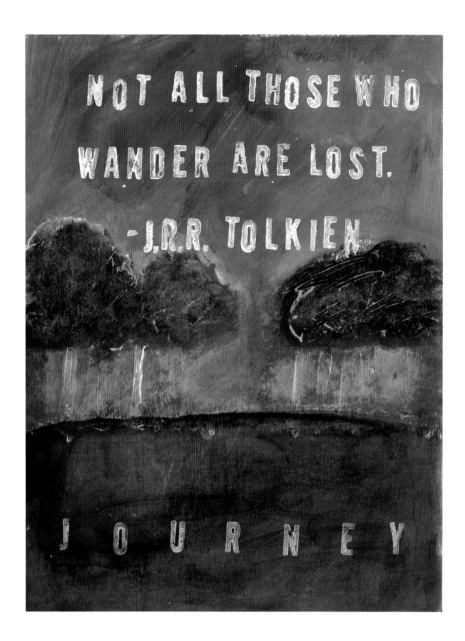

Rubber Stamped Letters with Gesso or Paint

One reason to work with gesso or paint instead of a permanent rubber stamp ink pad is that the paint dries just a little bit slower, so you have the chance to wipe off any errors and try again. This flexibility is wonderful for layout, but it's also great for people who have trouble making a clean imprint. I find that the quality of stamping with paint or gesso lends a more unique look. No one can stamp exactly the same as you when you use gesso. There is a wonderful imperfection. The advantage of using white gesso is that once the stamped letters are dry, you can add a color wash and the gesso will pick up whatever color you are adding. While you can stamp with heavy body acrylic paint, you would have to work too quickly, since the paint dries much faster both on your stamps and palette. If you want to work with a paint color, I would use Golden open paints. You can also mix up some tinted gesso—mixing a little gesso with some acrylic color. Your choice of paint color might depend on what will be most readable over your artwork.

Wander. Techniques used: acrylic painting, rubber stamped lettering with white gesso, color washes.

Have a painted piece of artwork ready for lettering. You'll need something to use to roll or paint gesso onto in order to stamp. If you have done block printing before, perhaps you already have a piece of Plexiglas, a metal plate, or a gel printing plate. Palette paper is nice for spreading the paint because it is not absorbent. I also like to use a piece of watercolor paper or other scrap paper that I can collage into another project later. A paper plate that has a nice glossy finish will also work well.

You will need to clean your rubber stamps immediately after use or the gesso will be permanent, particularly the black gesso. It's advisable to actually have two sets of the same rubber stamps if you want to keep one set for just stamp pad use and one set for getting messy with paint and gesso.

1 Draw guidelines onto painted art with water-soluble pencil if desired. Brush gesso in a smooth manner (not too thick or goopy) onto a plate or palette paper.

2 Stamp into wet gesso with a rubber stamp letter.

3 Stamp onto your art.

4 Immediately wipe off gesso from stamp with baby wipe or wet paper towel. If your stamp is complex, use a nail brush or toothbrush dipped in water to clean off the gesso.

5 Continue stamping with other letters, cleaning and drying stamps after each use. Use a small paintbrush to create punctuation that you might not have a stamp for, or do any touch-ups. Let dry.

6 Wipe off any guidelines you added.

7 Optional: Add color wash to any white letters if desired.

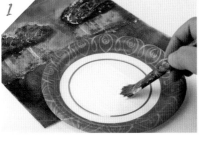

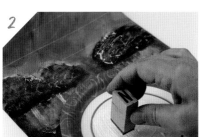

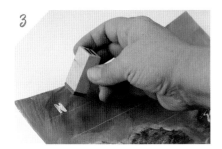

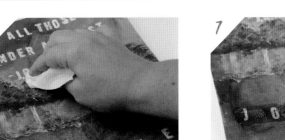

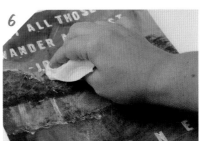

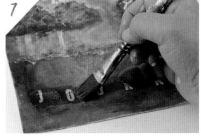

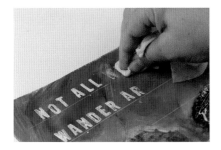

Wipe off any typos that have already dried with a paper towel dampened with nail polish remover.

Quick Fix: Misstamp Solutions

If you mis-stamp, you can wipe off a letter with a damp paper towel or baby wipe if it is still wet enough. If your letter or word has already dried, you can remove it with a little nail polish remover on a paper towel. Unfortunately, this most likely will remove a little of the background color paper as well. Repaint by dabbing and blending with a paper towel instead of a brush to avoid brushstrokes.

Variation: Rubber Stamping with Black Gesso

There is nothing so black and opaque as black gesso, especially Golden brand black acrylic gesso, which has a nice, fully mixed, jet black matte finish. It does dry a little faster than white gesso, so be sure to wipe off your tools quickly with a baby wipe or wet cloth. When working over acrylic paints, since your surface is sealed, you can wipe off misstamps easily before they dry.

The Center of Your Being. **Techniques used: acrylic paint, scribing into wet paint, gesso stencil, frisket masking, black gesso stamped lettering.**

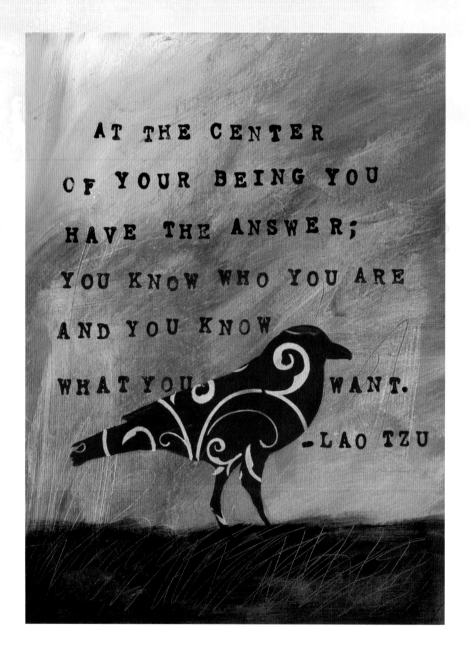

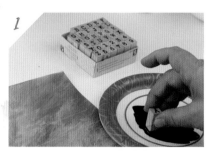

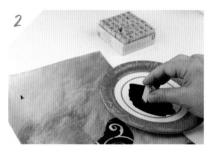

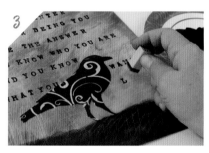

1 **Draw guidelines with water-soluble pencil on your painted artwork if desired. Brush black gesso in a flat manner (not thick or goopy) onto a plate or palette paper. Stamp into it with your alphabet stamp, then stamp on your guideline. When finished, clean stamp off immediately.**

2 **Continue to stamp, clean, and dry stamps. If your palette gesso has dried before you finish stamping all your letters, repaint with more black gesso.**

3 **Continue stamping the rest of your project.**

4 **Use a small paintbrush and black gesso to create punctuation. Let dry. Wipe off guidelines.**

Variation: Rubber Stamped Black Gesso Background Lettering

Since black gesso is permanent when dry, you can start a project with black gesso first and then layer your colors over the top. Just be careful not to bury your text with heavy layers of opaque paint. One layer of white gesso over the black gesso lettering will mask it with a slight translucency, so it is nice if you want more subtle text. I would still recommend working with a white gesso surface, before you stamp, so that if you make a misstamp you can remove it.

Far Away in the Sunshine. **Techniques used: stamped black gesso lettering, acrylic color wash, gesso stenciling on paper.**

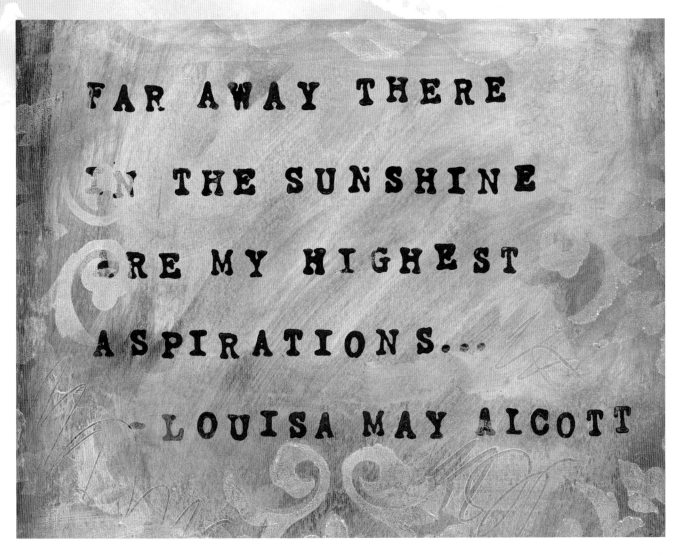

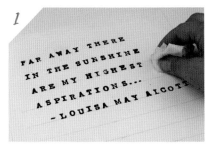

1 Draw guidelines, stamp text with black gesso, let dry. Wipe off guidelines.

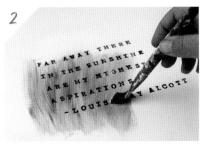

2 Apply a color wash.

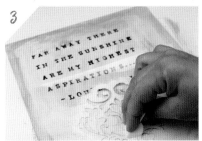

3 Continue with other decorative elements as desired, like stenciling, without covering up your lettering too much.

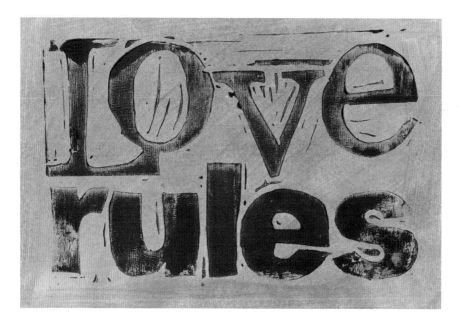

Love. Techniques used: block printing
(hand-carved rubber stamp), acrylic
paint, acrylic paint wash.

Materials Needed

- soft printing block
- word or short phrase
- tracing paper
- graphite transfer paper
- ballpoint pen
- block printing carving tool
- Sharpie or other permanent pen
- gel printing plate or Plexiglas/ metal plate for inking
- brayer
- fluid acrylics or open acrylics
- papers to print onto

Optional:

- Inktense block, crayon, or charcoal to test your design
- printer's baren or large spoon to rub back of print

Block Printed Hand-Carved Letter Stamps

Some of the most unique lettering—whether it's a single letter or whole words—can be created by carving your own rubber stamps. Block carving has come a long way since I was in school, when we had only those really hard linoleum blocks. Now we have eraser-like soft printing blocks that are super easy to carve.

The important thing to remember with block printing is that you'll need to flop your letter or words over so that they are backward when you carve them, so they will read correctly when you stamp with them. You can either use tracing paper and flip your design over and then carve that, or scan your artwork and flip it, using a computer program. You can transfer your design to your block using graphite transfer paper. Typically I like to work up a design on tracing paper so that it's easy to turn over and transfer onto the rubber stamp surface.

When carving rubber stamp designs, you also need to consider that you are carving *away* the parts of the stamp that you don't want to print. Sometimes this takes some getting used to. You can begin to carve your stamp and then actually pull a print to see what it looks like with paint. You can also place a piece of tracing paper over it and make a rubbing with the side of a crayon, Inktense block, or charcoal to see what kind of pattern you are getting. If you are taking a rubbing to check your design, remember to flip it over to see what it looks like from the front.

You can enjoy the rubber stamp you've created for years to come, in many projects. You could even do an entire alphabet that you can use with StazOn or other permanent rubber stamp pads or use a brayer to apply gesso or other fluid paints.

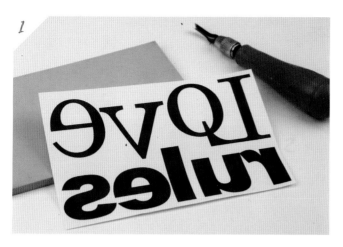

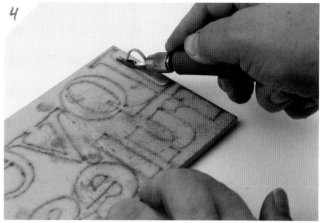

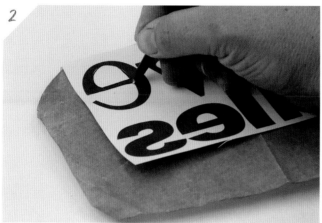

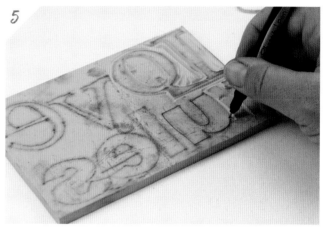

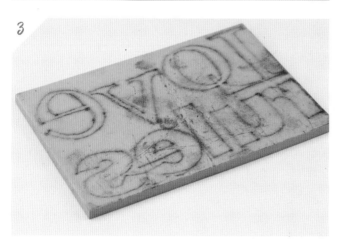

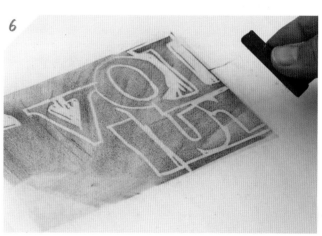

1 Design a short saying in a large font on your computer to use. Flip it in reverse before you print, or trace it with tracing paper and flip it.

2 Use graphite transfer paper (dark side down) and a ballpoint pen to transfer your design onto the rubber stamp block.

3 Reveal your complete design.

4 Carefully carve away all the parts of the stamp that are *not* inside the letters. You are carving away the background only. Use smaller carving tools for smaller spaces between letters.

5 If you smudge your guidelines, you can optionally retrace them with a Sharpie or other permanent marker to keep them visible as you carve.

6 Check your design periodically by using a sheet of tracing paper and a crayon, Inktense block (shown in the photo), or charcoal to rub the flat back and reveal your design, like taking a rubbing. Then flip it over to see if it reads correctly.

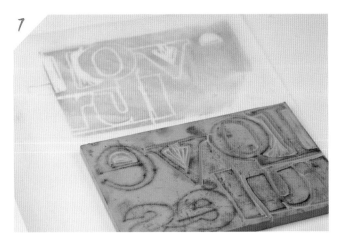

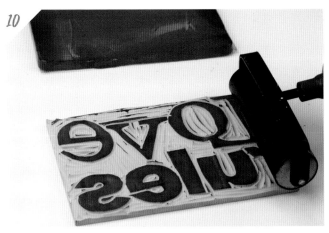

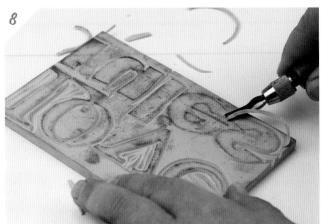

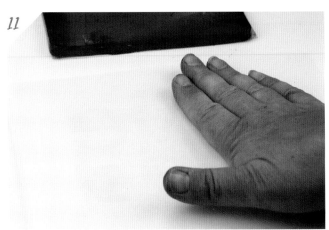

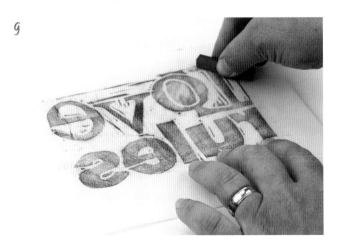

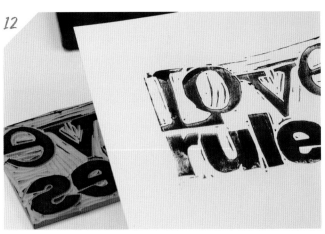

7 Continue carving away more of the background.

8 Don't forget to rotate the block as needed. Wiggle your tool rather than applying more force. Try to keep the hand that is holding the block behind your cutting tool to keep from injuring yourself.

9 Take another sample rubbing to check your design.

10 Use a gel printing plate, palette, or metal or Plexiglas plate to roll out some fluid acrylic paint with your brayer (roller) and apply paint to your carved block. (If desired, you can ink up your block with a rubber stamp pad. If your block is larger than your stamp pad, turn your stamp pad over and apply it to your carved block.)

11 Apply your paper and quickly burnish with your hand or a printer's baren (a tool used to rub the back of the paper to transfer print) or the back of a flat, wooden spoon.

12 Pull your print. Let dry. Apply color wash if desired and collage, or use as your main art and embellish as desired.

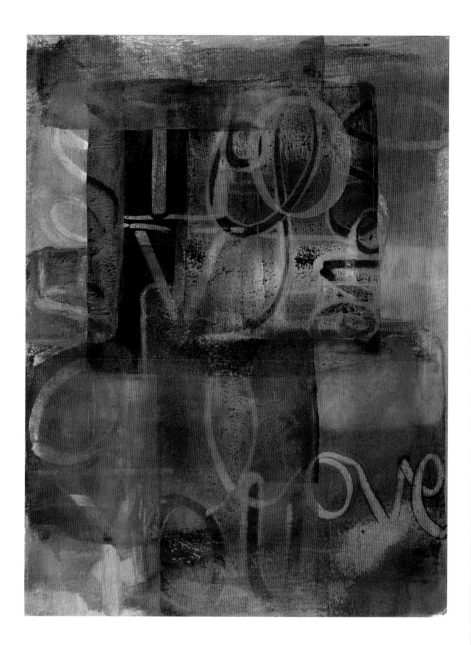

Gel Plate Printed Letters

If you haven't used a gel printing plate such as those made by Gelli Arts as well as other brands, buy yourself a small one (they come in a variety of sizes) and just start playing. There are a few books and hundreds of videos on using gel printing plates, and you will soon become addicted to pulling print after print.

When working with a gel printing plate, you need to work in reverse since we will be printing onto paper. It is like the gel printing plate *is* your rubber stamp. That takes a little getting used to. You cannot use regular rubber stamps on a gel printing plate because everything will print backward. There are some reverse rubber stamps that will work, or you can make your own designs on the surface of the plate. I like to take text from the computer and reverse it or flip it before printing. You can also use tracing paper and flip it over before placing under the gel printing plate.

Love Windows. **Techniques used: gel printing on watercolor paper with fluid acrylics, color washes.**

Fluid acrylics, craft acrylics, or open acrylics work best for this type of printing, depending on how quickly you work. Start with less paint than you think you will use. You can do designs and stencils and push in embossed papers and other techniques, but basically you will use a cotton swab or dual-tip cotton swab applicator to "pull" off the color exactly where your reversed letters show through the paint. You can still add another color of paint if you'd like, or start with a solid print of a light color. Place a sheet of watercolor paper over the top of the gel plate and use the palms of your hands to quickly rub over the back of the sheet to transfer the print. You can use a variety of papers—watercolor paper, copier paper, rice paper, even newsprint. It's recommended that you do not use glossy paper.

Gel printing plates can be used for a second or third print (called ghost prints) without adding more paint. You can also activate the remaining paint on the plate by spraying lightly with a little water. To fully clean off your plate, use a baby wipe or hand sanitizer and a paper towel.

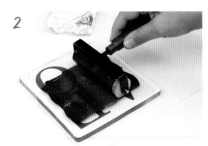

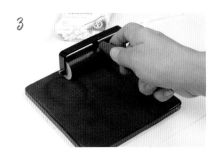

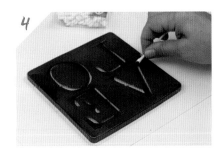

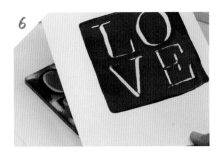

1 Print out your design in reverse.

2 Place the design under the gel printing plate. Apply paint in a thin manner so you can still see your design. Use brayer to roll the paint in one direction first.

3 Roll in other direction to fully spread paint.

4 Use a cotton swab or dual-tip cotton swab applicator to wipe areas inside your letters. Continue wiping off paint until you have finished your design. Use a clean swab when necessary.

5 Apply paper and quickly burnish with the palm of your hand.

6 Pull your print and set aside to dry.

A brayer.

Handy Tip: Brayer Etiquette

Here's a tip when using a brayer to roll out paint. When the brayer is fully inked, turn it upside down and set it on your work surface to pull a print. This will keep the paint off your work table. Do not let it sit too long or the paint will harden. Clean off the brayer by running it under water or wipe it with a baby wipe. If the paint has already set, soak the brayer in some warm water and use a scrub brush to clean it.

Variation: Collaged Deli Paper Printed Letters

Deli papers (which are lightly waxed) are luscious when collaged, since they are somewhat translucent. You can also flip your designs in reverse for collaging, so you can use regular rubber stamps if you like. Just be sure and use a backing sheet or several sheets of deli paper since it is somewhat porous. Apply soft gel or matte medium to your substrate and layer your deli paper, brush gel over the top and smooth out. Repeat.

Have a piece of art ready to collage with your deli papers. It can be a painted project or an already gel printed paper design.

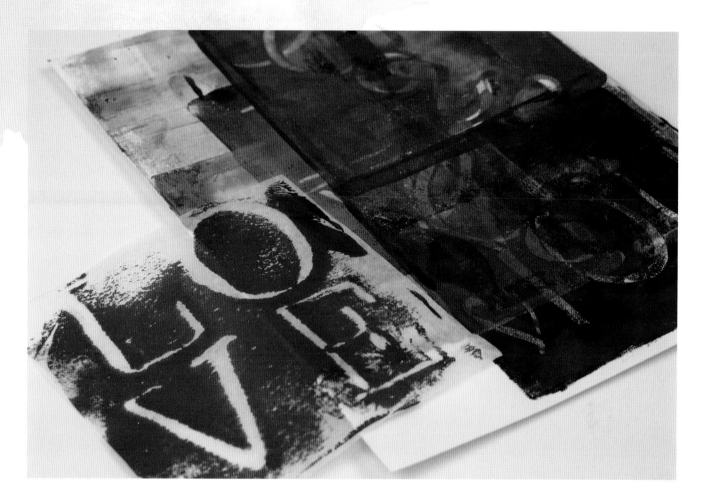

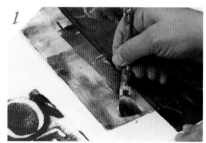

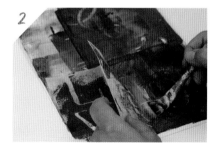

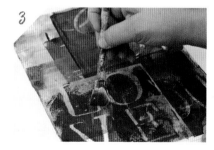

1 Paint a one-inch-wide area with acrylic soft gel or matte medium. Working from left to right or top to bottom, attach the deli paper into your gel.

2 Slowly continue to add more gel and roll your deli paper print down onto the surface. This will ensure that there are no bubbles underneath.

3 Brush gel over the top of your deli paper, smoothing out the surface carefully. Let dry or apply more collaged deli paper. Let dry. Optional: Apply a color wash to your collage if desired.

Variation: Gel Printing Plate and Stencils

You can use stencils in a variety of ways. You can brayer acrylic paint onto the plate first, set down a stencil, and pull a print, carefully pressing into the centers of the stencil areas to transfer the paint. Or, use a cotton swab to wipe away the ink from the center areas of a stencil before you pull a print. You can lay down a solid color print first, place your stencils, and add a second color. You can even take a print from your wet stencils! Thinner paper works best for techniques where the stencils are left on the gel plate when pulling a print.

1

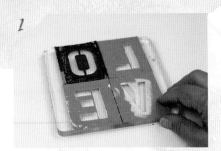

3

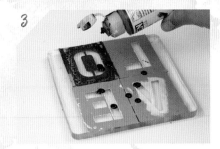

5

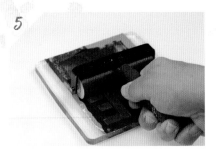

2

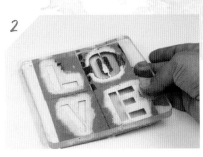

4

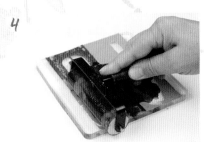

6

1 Apply stencil to the surface of unpainted gel plate so that it reads backward. Make sure the seal is nice and tight.

2 If you are unsure if you have placed your individual letters in the right direction, turn over your gel plate to double check.

3 Apply paint directly over the top of the stencil.

4 Don't apply too much pressure or the stencils might move. Roll paint over top of stencil.

5 Roll paint in both directions to cover and allow the paint to flow into the stencil centers.

6 Apply paper and burnish with your hand, especially in the areas inside the stencil.

Pull your print. Repeat with other letters, stencils, and papers.

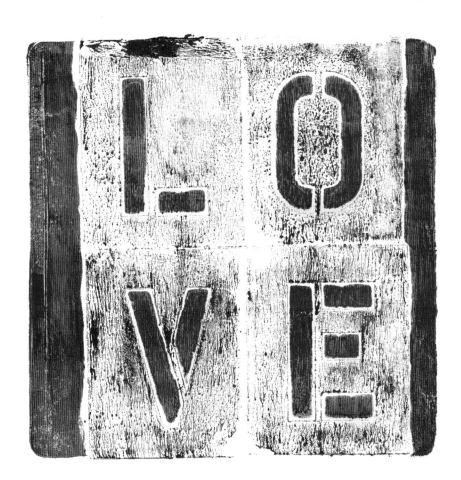

Variation: Craft Foam Stamp and Gel Printing Plate

This is a fun and simple way to get words onto your paper, whether it is deli paper or watercolor paper, or even office copier paper. Check out the huge supply of three-dimensional alphabet stickers in the scrapbooking section of your local craft or hobby shop. You do not have to work backward, so it is easy to space them out onto a piece of scrap cardboard or mat board.

Wish, Grow, Hope. **Techniques used: gel printing onto watercolor paper with acrylics and craft foam stick-on letter stamps, color wash.**

1 **Use stick-on craft foam alphabet letters to create your handmade stamp on a piece of scrap cardboard or illustration board.**

2 **Apply paint to your gel plate with a brayer.**

3 **Take the craft foam stamp and get ready to place it onto the plate carefully. It will be a little slippery.**

4 **Apply stamp and press gently without moving the stamp.**

5 **Carefully lift off stamp to reveal plate.**

6 **Pull a print with paper or deli paper.**

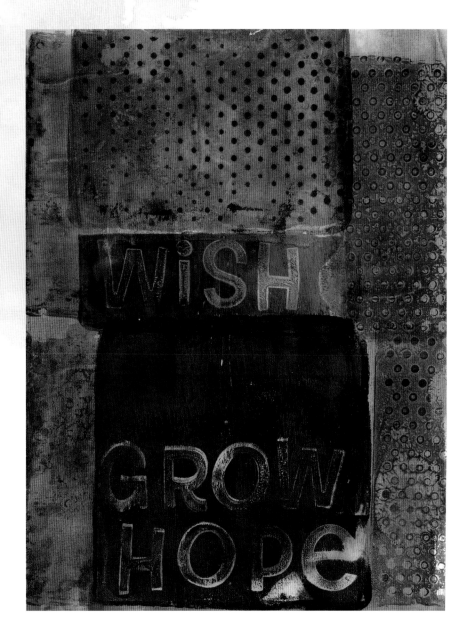

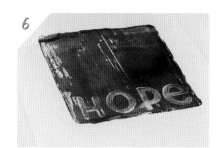

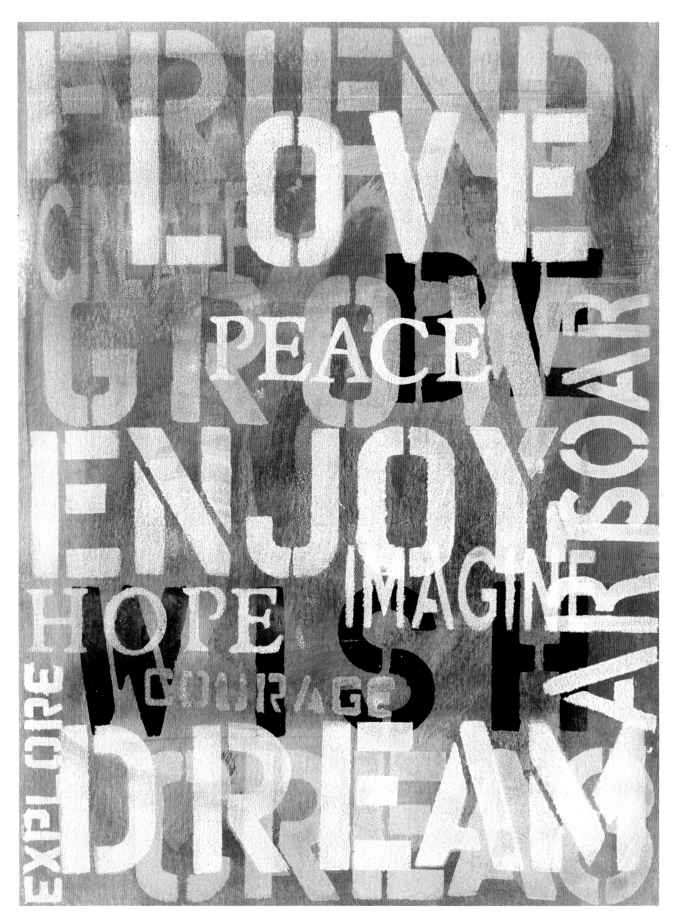

Love, Enjoy, Dream. **Techniques used: acrylic painted background, white gesso stenciled words, color wash, black stenciled words, color washes on watercolor paper.**

STENCILED

Stenciled Letters

There are so many lovely stencils available on the market now. You can find basic stencils at art supply stores, fabric stores, craft stores, and hardware stores. You can also find lots of alphabet stencils online, including from companies that will create custom stencils. Individual alphabet stencil sizes range from very small up to 48". I like the simplicity of the classic hardware store cardboard stencils that you don't have to worry about cleaning; just let the paint built up and make the stencils stronger.

I also really like handmade stencils. There's something fantastic about making your own stencils; besides saving a bit of money, you can also create less than perfect lettering whether you use your own handmade designs or trace a font from the computer.

One thing to note about full sheets of alphabet stencils: There are parts of some letters, like "O," that have two-part stencils, so you can paint with liquid frisket or mask with tape the center part when you stencil, or let it fill in if you like. You will also have to wait for one letter to dry if you are spelling something out that requires moving the stencil over paint you have just applied. A heat gun will help speed up your drying time, so you can move an alphabet stencil around more quickly.

You can use a stencil brush or pouncer, but I prefer disposable foam makeup wedges that you can get at the drugstore. You can also use a normal brush or flat foam brush if you can hold your stencil tightly and don't mind a little bleeding under the edges of your stencil. I like using paint in a dry method, applying more than one layer if necessary with a makeup wedge to get a nice solid coverage. If you use white gesso, when it is dry you can apply a wash of color to make it a different color. You can also use tinted gesso, fluid paints, craft acrylics, or open paints to stencil with, but regular heavy body acrylics dry a bit too quickly for this method.

Materials Needed

- acrylic paints
- white and black gesso
- 9" x 12" sheet of hot press watercolor paper, canvas, or wood panel
- alphabet/word/phrase stencils
- water container
- paper towels
- 1" flat brush, 1/4" flat brush, and/or pointed brush for details
- baby wipes
- sandpaper (medium grit)

Optional:

- Micron or PITT pen for outlining/highlighting
- alphabet or word/phrase computer printout in larger lettering
- pattern stencils
- makeup wedges
- paper plates or palette paper
- scribing tool or toothpick
- graphite transfer paper
- tracing paper
- ballpoint pen
- manila file folder/card stock

1 **Apply gesso to a plate or palette in a flat (not goopy) manner.**

2 **With an up-and-down motion, use a makeup wedge to pick up some paint from the plate.**

3 **Apply gesso through stencil onto your art.**

4 **Use a heat gun to speed up drying. Make sure your stencil is dry before you lay another stencil near it or over it. Continue to stencil. Let dry or heat dry.**

5 **Brush or dab on color wash with dampened paper towel. Let dry.**

6 **Apply a different color wash. Let dry.**

7 **Apply black gesso (use a clean, dry plate) with a clean makeup wedge through another stencil.**

8 **Let dry, or speed up drying by using a heat gun.**

9 **Continue to apply layers of white gesso again through stencils.**

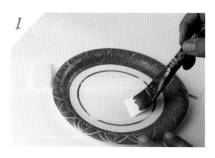
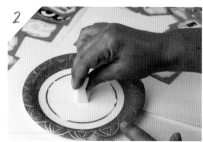
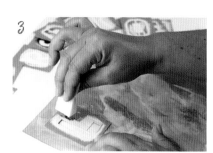
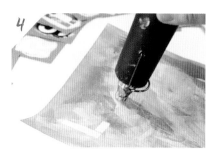
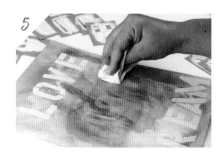
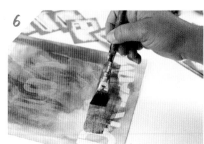
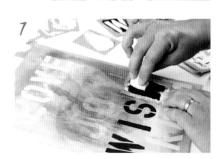
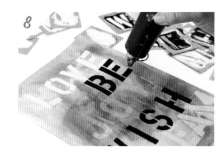
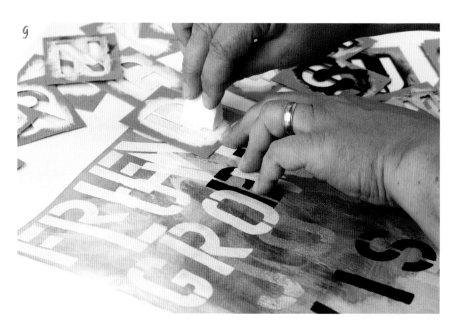

Cleaning Your Stencils

If you use a commercial plastic or even handmade acetate or Mylar stencil, you will need to clean your stencil directly after using. If you have plastic stencils, you can just run them under the faucet and scrub with a sponge. If you are not near a water source, you can wipe off with a damp paper towel or baby wipe after use. Cleaning your stencil will keep it remaining as flat as possible and also protects the small delicate areas from filling in with paint. Layers of paint buildup will interfere with your stencil, but sometimes I like that imperfection. Craft acrylics left to dry on a stencil may flake off in the future and interfere with paint application, or they may stick to your surface. You can also soak plastic stencils in a dish pan with dish soap and water overnight to help loosen caked-on paint, then scrub with a kitchen or bathtub scrub brush or dish cleaning brush or Teflon coated sponge. You can also choose to use a latex paint remover. Set the stencil on paper towels or wipe off to dry.

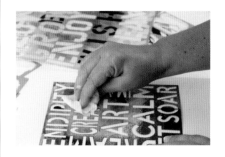

Wipe off your stencil immediately after use by running it under water. Or, use a baby wipe or damp paper towel.

Handy Tip: Masking

Whether you have a handmade stencil or commercial stencil, in some font designs you might have an issue when you get to letters like "o," "b," or "p," which sometimes have a separate center piece or what is called an "island." I like to use painter's tape to cut out the small center part of these types of letters and place the tape carefully as a mask where I stenciled the outer part of my letter. When the letter has dried, I can easily remove the mask.

1 Place a piece of blue painter's tape over the center shape of the capital "O." Draw the outline of the shape with a pencil or pen.

2 Peel off the tape and cut the shape with scissors or an X-Acto knife. Place it in the center of the capital "O" stencil before you stencil it.

3 Reveal your print and remove the taped center.

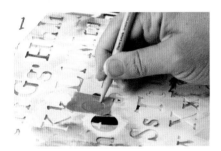
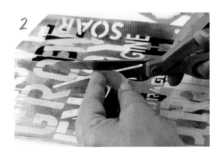

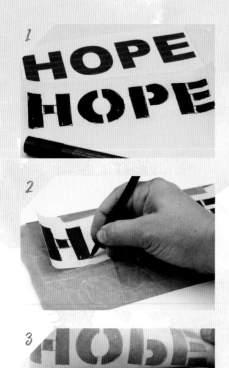

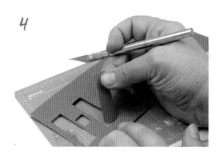

Variation: Hand-Cut Paper Stencils

Handmade stencils can be made by creating lettering by hand or on the computer to the size and scale you need. The stencil can then be transferred, using graphite transfer paper onto card stock or an old manila file folder and cutting out the middle of the design. As you cut out your design, you will realize that you cannot create "islands" or your design cannot be cut into a stencil. An example of an "island" would be the center of an "O." The center piece would have to have a bridge to the rest of the letter. Take a look at commercial stencil letters to see how they are designed.

Bristol board, index card stock, or manila file folders work well to cut paper stencils, and you don't need to clean them off afterward. Manila file folders are a nice thickness and take a good beating for use and reuse. Frequent applications of paint will strengthen any paper stencil. When cutting a stencil with an X-Acto, use a ruler for straight lines. When cutting curves, take them slowly, using a brand new sharp blade. Try rotating the paper rather than the blade or use an X-Acto with a swivel tip.

For the see-through aspect, you might like to use clear acetate or Mylar to see more easily where you are placing the stencil. You can copy your design onto acetate at your local copy store or draw or trace it onto Mylar you purchase. A stencil supplier will also offer several thicknesses of Mylar that you can use with a stencil burner if you like. I like the thicker weight Mylar; although harder to cut, they end up lying flatter for stenciling. A stencil burner has a heated tip that cuts by melting the plastic and makes it a lot easier to create curved shapes. Make sure you use a stencil burner over a tempered glass or metal surface, to protect your worktable.

1 Use a font printed from your computer and design it for a hand cut stencil so that it does not have any "islands."

2 Use graphite transfer paper to transfer your design to a thicker stock, such as an old manila file folder or index card stock.

3 Check to make sure your layout is transferring.

4 Carefully cut out the center of your letters with an X-Acto knife.

Numbers Game. Techniques used: blind stenciled gesso, color washes, stenciled white gesso, stenciled black gesso on paper.

Variation: Scribing Inside Wet Stenciled Paint

Simple stencils do not have to stay that way. When you apply paint or gesso through a stencil, while it is still wet you can carefully use a pencil, toothpick, embossing tool, or any other tool to scribe into the wet paint with a pattern or outline. Optional: Add a paint wash when the scribed stencil has dried.

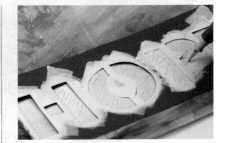

While gesso inside a stencil is still wet, scribe into it with a tool to make textures, or patterns, or simply outline the letters.

Handy Tip: Save Your Stencil Scraps

When creating paper stencils with large fonts, or if you are punching out a hardware store stencil, it's a good idea to keep the extra parts. They can be used to mask areas on future projects. When using stencil scraps, stick them down with poster putty, a little painter's tape, a repositionable glue stick, or stencil spray to keep them from moving as you apply paint over the top.

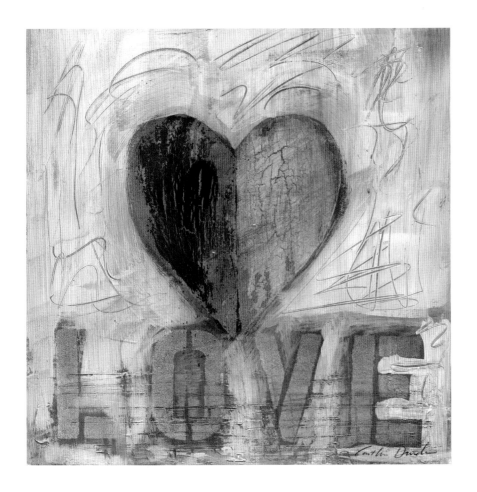

Weathered Heart. Techniques used: black gesso background, acrylic paint, stenciled heart, gesso stenciled word, scribing into wet gesso, crackle gel, color washes.

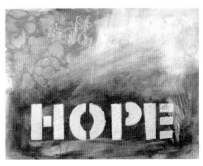

Hope. Techniques used: handmade stencil with scribed gesso over Inktense-painted background with reverse stencils and color washes.

Secret Alphabet of Dreams. Techniques used: acrylic paint, gesso stencils, scribing into wet paint, pointed pen calligraphy with acrylic ink, color washes.

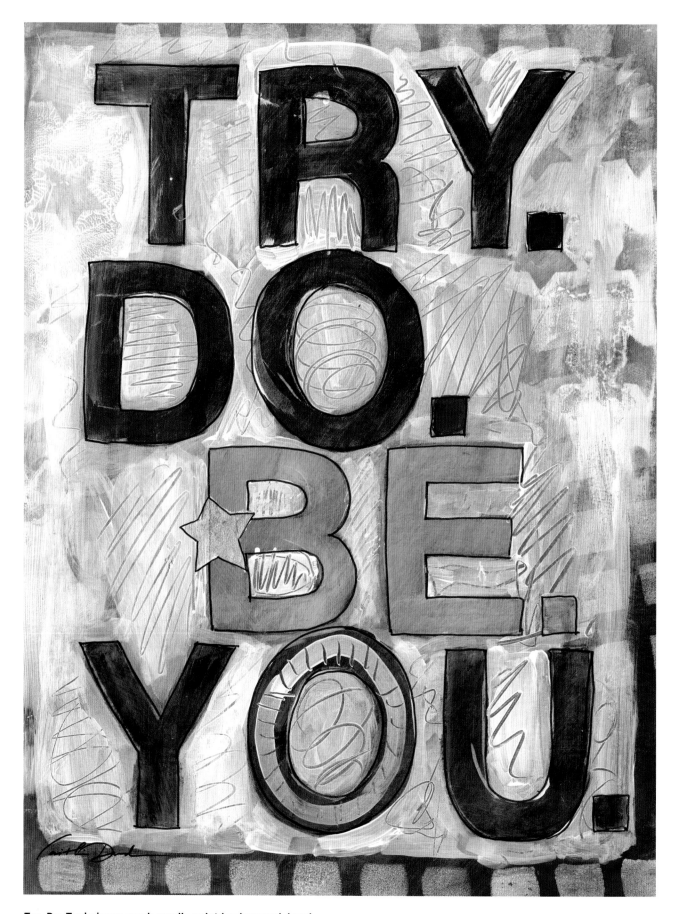

Try. Do. Techniques used: acrylic paint background, hand-painted letters, overpainting, scribing into wet gesso.

HAND PAINTED

Hand-Painted Lettering

Back when I was in college at the end of the '80s, computers like the Mac started to revolutionize typography, basically putting it into the hands of everyone and anyone. But being on that cusp, we were still taught how to hand letter large typography for magazine and brochure layouts. It's a practice that might be dying out these days, as even sign painters don't do a lot of work by hand, but it's nice to be able to create some letters for artwork. Rather than hand drawing, I like to use a copy machine (or computer) and graphite transfer paper. Once you get the hang of this technique, you'll find you might enjoy making graphic art with lots of large letters and numbers.

Find a font that you like, either in a typography book or on the computer. Use a copy machine to enlarge the letters you need to the size you want, or print them out on the computer to the size you want. Typically I like working with individual letters; that way I can space them out visually on tracing paper over my artwork with the kerning (the space in between letters) and leading (the space between each line) that I want. You can also play around with ways to overlap letters if you like. You can use a ruler for the straight parts, but doing them freehand will also lend a nice handmade look to the letters.

Letters can be entirely hand painted, or you can detail them with scribing or outline them with pencil, Micron, or other pen. Sometimes I outline with black pen, sometimes with white; whatever makes the letters stand out the best. I often use a pointed pen dipped in high flow or acrylic ink to create crisp outlines, but this does take longer to dry. I have found that carbon black high flow paint by Golden is the most waterproof of all the black inks. For waterproof white ink, while Golden high flow is nice and waterproof, I find that FW white artist's acrylic ink is more opaque.

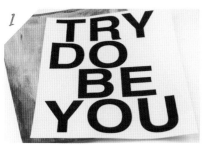

1 Print out the words you want to use and have a painted background ready.

2 Using graphite transfer paper, trace your design onto your art.

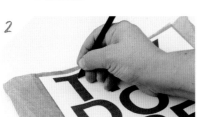

Materials Needed

- painted artwork
- white gesso
- acrylic paints
- alphabet or word/phrases computer printout in larger lettering
- 1" flat brush or mop brush, small pointed or flat bursh for details/outlines
- graphite transfer paper
- tracing paper
- ballpoint pen
- paper towels
- water container
- baby wipes

Optional:

- Golden Titan Buff heavy body acrylic
- disposable makeup wedges or pouncer
- toothpick or other tool for scribing
- medium and fine grit sandpaper
- PITT or Micron pen for outlining
- pattern stencils
- paper plate or palette paper

3
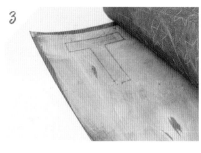

4
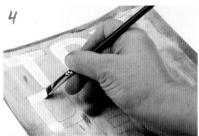

5
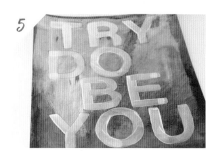

6
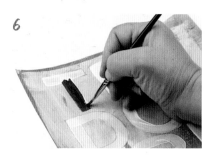

7
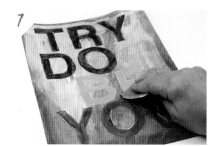

8
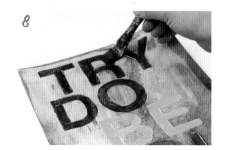

9
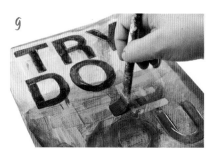

10
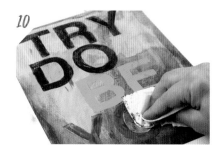

11
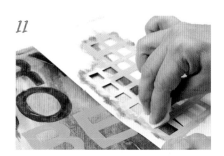

12
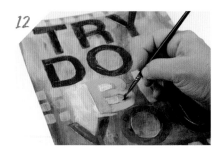

13
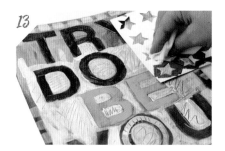

14

3 Check to make sure the transfer is working. Continue until you have transferred the whole design.

4 Use white gesso and a small paintbrush to paint inside your letter design. Use more than one layer of gesso if you want.

5 Continue until you have painted your entire design in white gesso. Let dry.

6 Paint a color inside the letters over the white gesso. You can paint individual letters in multiple colors or the same color. Continue until you have painted your design fully. You can stop here if you like your art.

7 Use medium grit sandpaper to remove some brushstrokes and add interesting texture to your art.

8 Apply a color wash to the entire project or only a portion.

9 Apply another color wash.

10 Buff color around the surface with a paper towel or cloth.

11 Apply some stenciled gesso or other design elements over or around your lettering.

12 Work with white gesso or off-white paint like Golden's Titan Buff to highlight the background behind some letters.

13 Apply more stenciled layers.

14 Apply more gesso or off-white paint and scribe around your letters. Let dry. Optionally, add another color wash.

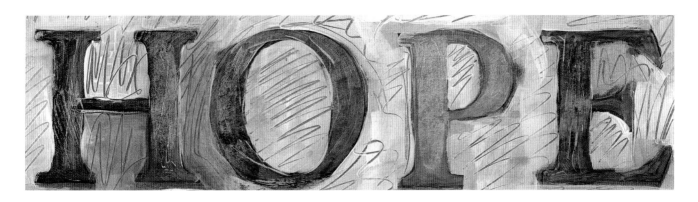

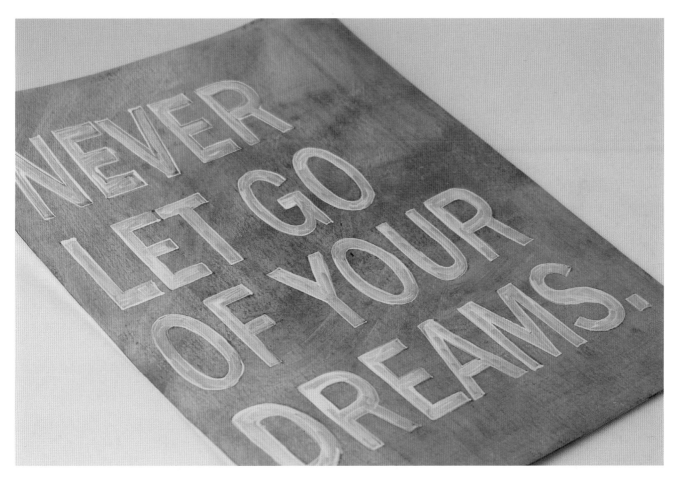

Hope (close-up). Techniques used: painted acrylic background, painted lettering, sanding back, painting behind letters, scribing into wet paint.

Never Let Go. Techniques used: painted acrylic background, gessoed and hand-painted letters.

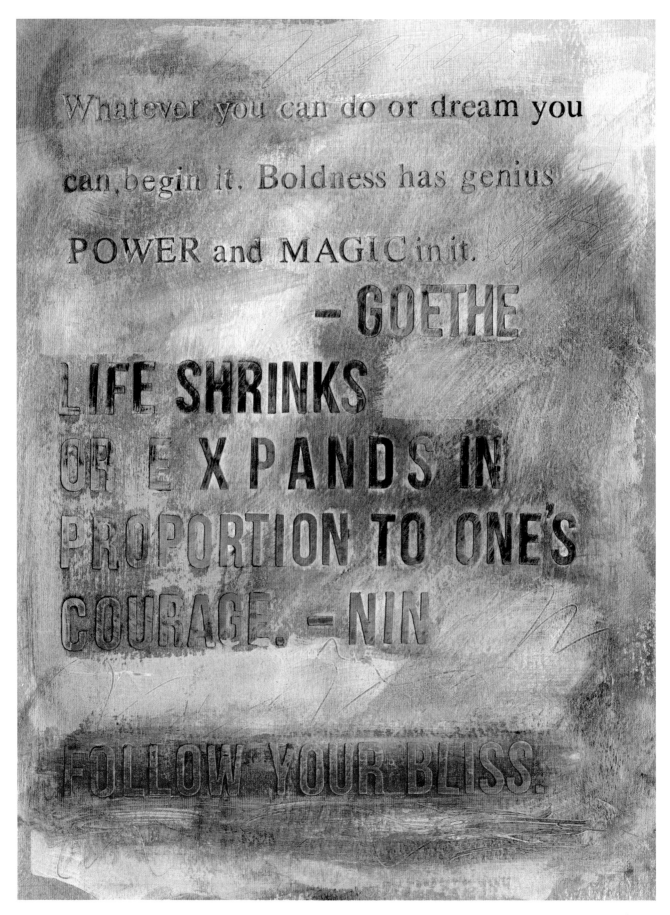

Follow Your Bliss. Techniques used: stick-on letters, gesso
scribing, acrylic color washes.

STICK ON

Stick-On Letters

There are so many rub-on and stick-on letters available now, thanks to the popularity of scrapbooking. Years ago, graphic designers used rub-on letters that were a bit fragile and couldn't be removed and repositioned easily, but now we have access to a plethora of sizes and kinds of letters, and some are very repositionable. You can choose from different colors, including sparkly letters if that's what you want. I think it is wonderful to use them as a starting point and then take it to the next level. By painting over and around your letters, you can really create something that is more your own. You can choose to work with serif fonts, which are characterized by an embellishment at the base that looks like a little foot, or sans serif fonts that are simple, block letters. You can also choose from a variety of stickers that come in calligraphic or handwritten styles too. Whatever style you choose, make sure that you get more than one set of alphabet letters. If you are writing full sentences, you don't want to run out of the popular vowels. Most adhesive letters are pretty strong, but to be sure of their adhesion you can coat with a layer of clear or matte acrylic soft gel when you have finished painting your project.

Materials Needed

- graphite pencil and eraser or water-soluble pencil
- watercolor paper or canvas, etc., primed with white gesso
- stick-on alphabet letters
- embossing tool
- white gesso
- brayer
- 1" flat or mop brush
- acrylic paints
- paper towels
- water container
- baby wipes
- scribing tools (toothpick, tip of brush, etc.)

Optional:

- tweezers
- X-Acto knife

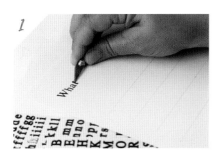

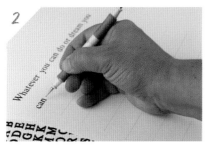

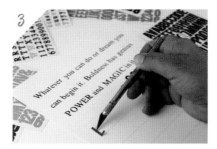

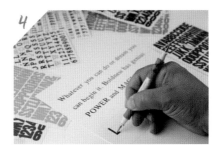

1 Draw graphite pencil guidelines or water-soluble guidelines on a white gessoed substrate. Begin applying stick-on letters. Use tweezers or an X-Acto knife for assistance.

2 Press down the letters with an embossing tool or the tip of a brush.

3 Continue to add letters. Use different colors if you like. Try to avoid repositioning as much as possible, since it weakens the stickiness of the letters.

4 Make sure letter is straight before burnishing it down.

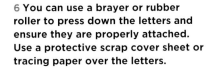

5 Depending on the size of the letters and your dexterity, you can apply them with your fingers.

6 You can use a brayer or rubber roller to press down the letters and ensure they are properly attached. Use a protective scrap cover sheet or tracing paper over the letters.

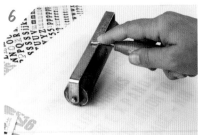
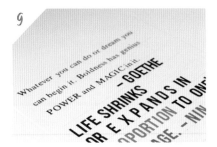

7 Continue with your phrases, spacing out words as desired.

8 Cut unused letters to create punctuation you might be missing.

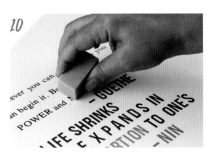

9 Continue until you have filled your page or completed your design. Check for spelling errors.

10 Erase your guidelines if you made them in pencil, or wipe them off very gently with a slightly damp cloth if you used a water-soluble pencil.

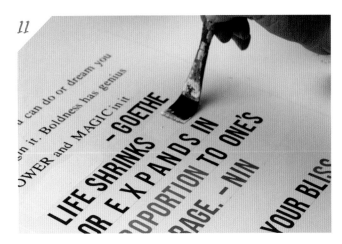
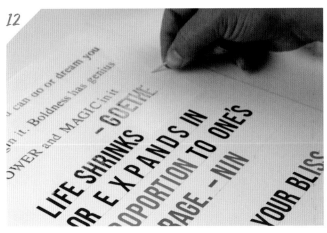

11 Apply light gesso wash around and slightly over the letters.

12 Optional: Scribe into wet gesso if you like.

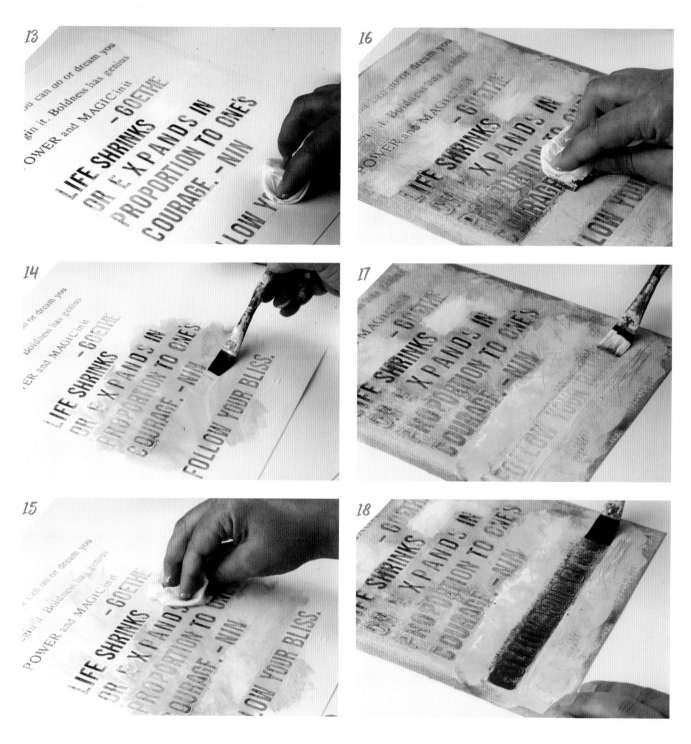

13 Buff, spread, and lift any excess gesso with a paper towel. Let dry.

14 Apply a color wash.

15 Move the color around with a paper towel to make sure the lettering is still readable.

16 If any letters have too much paint, wipe them off gently with a baby wipe.

17 Apply more gesso if desired. Let dry.

18 Appy color wash in gessoed areas.

THOSE WHO SAY IT
CAN'T BE DONE ARE
USUALLY INTERRUPTED
BY OTHERS DOING IT
—JAMES BALDWIN

Uncovered and Deconstructed Letters

RESIST

Remember when you were little and you wrote someone a message in lemon juice and held your note against a light bulb to reveal it? There is something fun and magical about lettering that becomes revealed through a certain process, even if you knew it would be there. You might have already created a project that has so many layers of collage and paint that any words might have become a little hidden or unreadable. I think that makes it more interesting, but certainly if your personal goal is to have a piece that is readable by the viewer, then you need to make sure your text is not fully buried. I often do lettering as the final step, but some of the following techniques will show you what happens when you start with lettering and build and reveal (or not) as you go.

In this chapter, we'll explore mysterious blind embossing with embossing powder and another technique with white gesso; we'll introduce embossing pens, reverse stenciling, and masking with stick-on letters. Working with resists or masks is a wonderful way to protect your surface, reveal your message, and make some lovely art. I really enjoy using liquid frisket. Primarily used by watercolor artists, it can be used to create letters, allowing for greater flexibility and for spontaneity in painting.

Doing It. **Techniques used: Incredible White Mask liquid frisket hand lettered with paintbrush, acrylic painting on paper.**

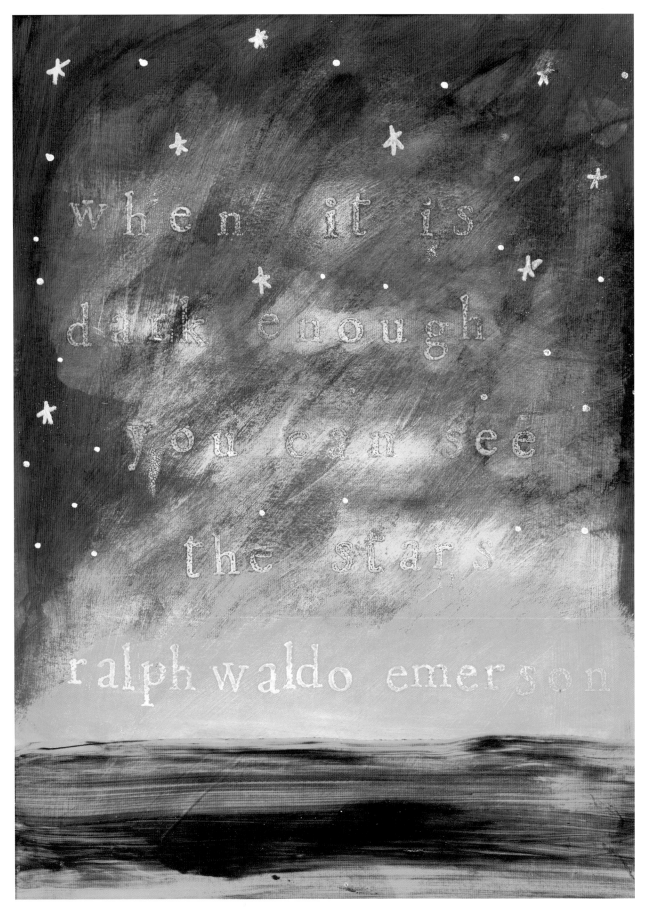

See the Stars. **Techniques used: clear embossed, stamped resist letters; hand drawing with embossing pen; acrylic paint on paper.**

Rubber Stamp Embossed Resist Letters

In Chapter 1, I used embossed lettering as a final step in my artwork. For resist lettering, we can create embossed lettering *before* beginning the painting process to create some more subtle and interesting effects. Clear embossing powders are used for this technique, with clear watermark or stamp pads labeled specifically for embossing. If you can find an embossing pad that is tinted; it will be easier to see on your substrate if you are working on a white background. You can then use clear embossing powder and a heat gun to create some permanent raised letters that you can paint around and over without disturbing the lettering. You can start with a white gesso-primed surface or a surface that has been painted with a color already. The color will appear in a very subtle manner below any paint colors you create over the top. It is nice to do a bright color surface, clear emboss, then add a darker color over the top.

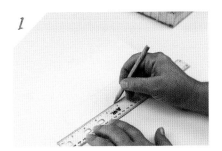

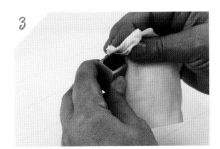

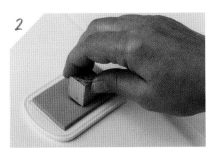

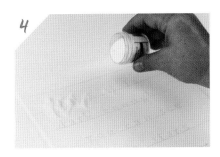

1 Draw guidelines if desired onto white gesso-primed surface.

2 Use a tinted embossing stamp to stamp your letters. Apply slightly above your guideline if possible.

3 Clean off your stamps as you go with a baby wipe or stamp cleaner.

4 Sprinkle embossing powder onto stamped letters.

Materials Needed

- 9" x 12" sheet of hot press watercolor paper, canvas, or wood panel
- graphite pencil and eraser or water-soluble pencil
- ruler
- embossing stamp pad (tinted pink)
- alphabet rubber stamps or words
- baby wipe or rubber stamp cleaner
- clear embossing powder
- acrylic paints
- 1" flat brush or mop brush
- heat gun

Optional:

- X-Acto knife or tiny brush
- embossing marker
- metallic embossing powder
- colored embossing powder
- white embossing powder

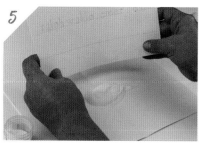

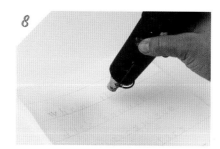

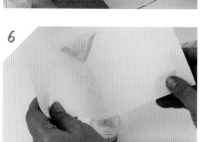

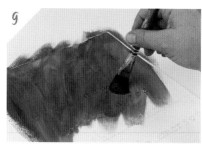

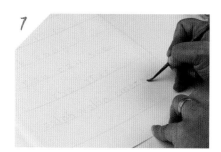

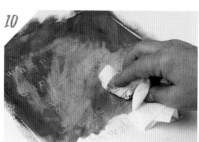

5 Tip off excess embossing powder.

6 Return excess embossing powder to container.

7 Use a dry brush or X-Acto knife to remove any overstamping.

8 Apply heat gun to melt the embossing powder.

9 Apply paint wash over your embossed letters.

10 Wipe off the tops of the letters with a paper towel or baby wipe to reveal the clear white letter beneath.

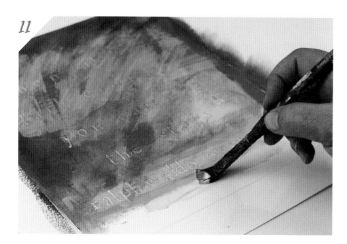

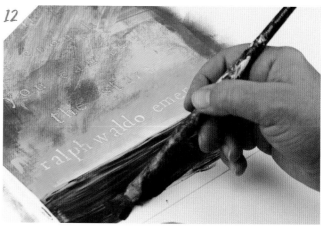

11 Continue to apply paint washes or additional design elements.

12 Continue with other colors of paint if desired. Let dry.

Optional: Embossing Pen

We'll use embossing pens more in the next section, but sometimes you need punctuation (that is not always included in all sets of alphabet stamps), outlines, or other touches that match your embossed lettering. There are a couple of companies that make embossing pens. They are basically sticky markers in either black or clear. Use them the same way you use a pen on a dry surface: sprinkle on embossing powder and apply heat.

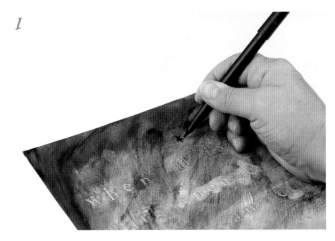

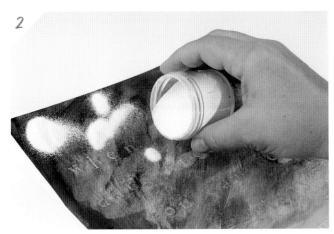

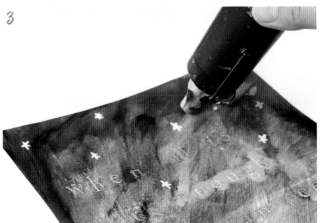

1 Apply more designs to the top of your art. Use an embossing pen to draw other lettering or designs.

2 Sprinkle embossing powder over new art. Tip off excess powder and return it to the container. Brush away any excess powder on your art.

3 Apply the heat gun to each element to emboss.

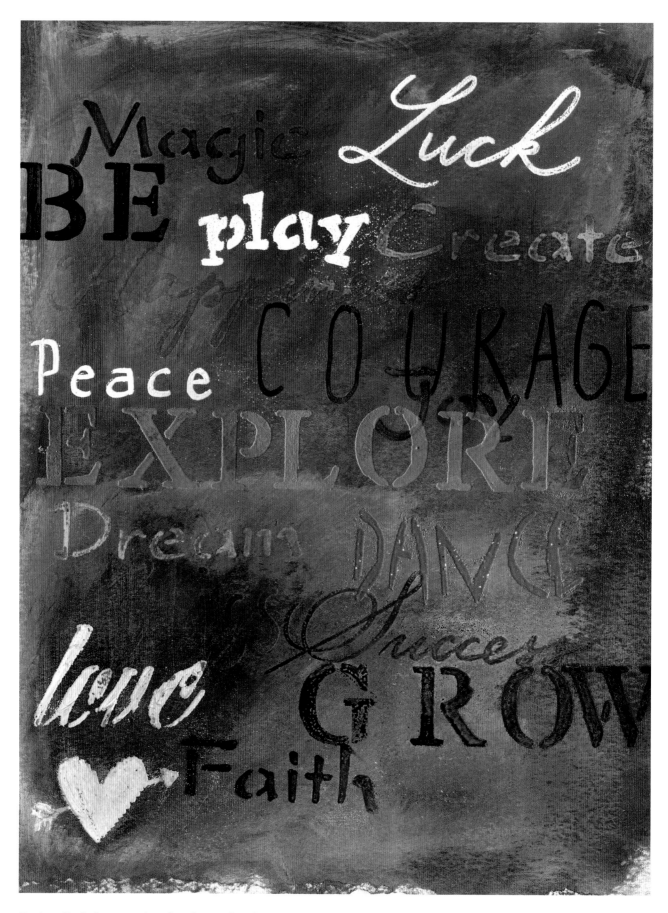

Explore. **Techniques used: embossing marker through stencil
in resist with embossing powder; handwritten embossing
marker resist; embossed stencil and embossed handwriting in
metallic gold, black, and white, acrylic color washes.**

Embossing Pen Letters

Embossing pens have that same sticky fluid that comes in the embossing pads. I have seen several brands both in black or white (clear) with either a brush tip or medium point felt tip. You can use clear if you want to continue with a resist-style effect or use other colors to simply create some beautiful results.

You can use these pens to outline, or outline and fill through a stencil for wonderful results. You can also try them for some freehand writing. I like using a white or clear embossing pen for this technique; however, it is hard to see when you write with it. While you can write with black and use a different color of embossing powder, white embossing powder creates the best results with the clear embossing pen so the colors in the embossing powder are nice and solid.

Materials Needed

- painted artwork (with dark background)
- embossing marker (clear or black)
- embossing powder (white, metallic gold, colors, etc.)
- alphabet stencil or stencil words
- heat tool
- baby wipe or rubber stamp cleaner
- X-Acto knife or tiny brush

1 On a painted, light-colored background or white gesso-primed surface that is dry, place your stencil and use a black embossing marker to fill in the center of the stencil design.

2 Continue using embossing marker to fill in the whole word.

3 Remove the stencil and sprinkle clear embossing powder. Tip off excess powder and return it to the original container.

4
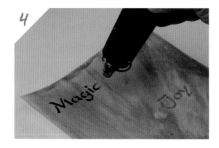

5
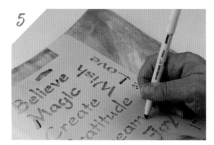

6
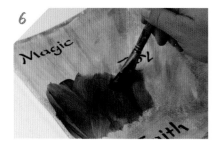

7
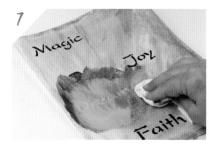

8
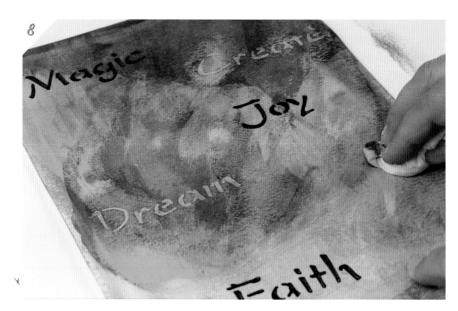

9
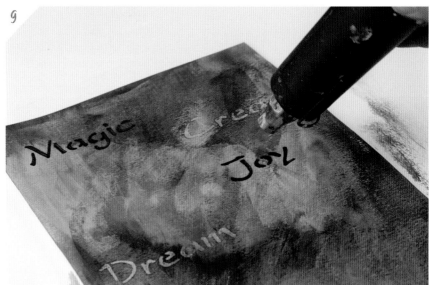

4 Apply heat to emboss fully. Make sure you activate the powder. Clear embossing powder used over black embossing marker creates subtle black raised lettering.

5 Apply embossing marker through stencil in another spot; this time try the clear embossing marker and use clear embossing powder on this word. Apply heat to emboss.

6 Apply a dark paint wash.

7 Buff the paint around, cleaning off the tops of the letters you have embossed with a paper towel or cloth.

8 Continue buffing paint around and over your lettering.

9 Try embossing with metallics or other colors, too. Apply heat to activate or melt the powder in the same manner as other colors. You can use the black embossing marker for these colors since metallic paints are dark enough to cover the black embossing marker.

Optional: Freehand Cursive Embossed Letters

Once you have a marker in your hand, it becomes an instant tool for writing, touching up rubber stamp imprints before embossing, and basically having fun making some magic writing. Make sure the surface you are writing on is completely dry. You can draw a guideline in water-soluble pencil, but be aware that if you use transparent embossing colors you will still see any portion of the line that is underneath any lettering.

1 Try some handwritten lettering with the embossing marker. It will be hard to see if you use the clear pen.

2 Sprinkle on clear embossing powder or try another color.

3 Apply heat to emboss the lettering. Continue with other embossing or paint layers as desired.

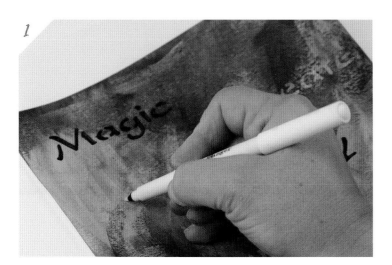

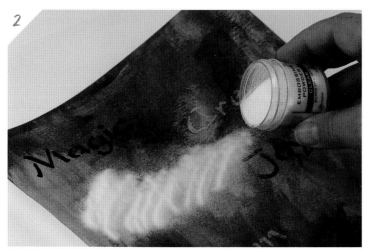

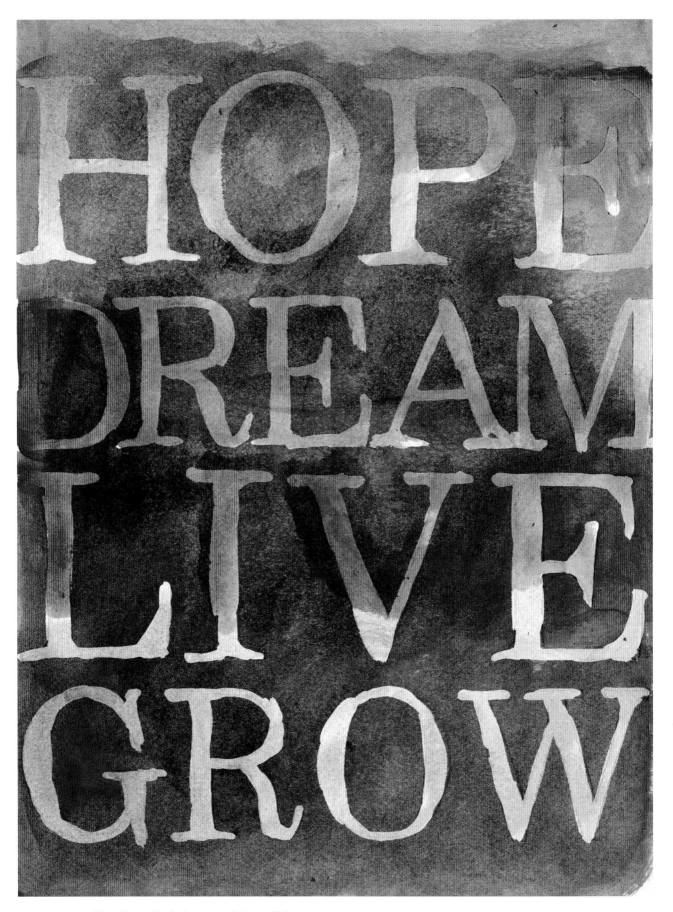

Hope, Dream, Live, Grow. **Techniques used: Incredible White Mask hand-painted lettering, acrylic wash over watercolor paper.**

Liquid Frisket Letters

Masking fluid, sometimes called liquid frisket, has been used by artists for years for a variety of techniques mostly involving watercolors and inks. When dry, it is sort of like that sticky substance you have to pull off your new credit card when you get it in the mail. Often an artist will paint an area with masking fluid and then, once it is dry, will cover a large area with paint or ink. The area covered with masking fluid will stay white or hold whatever color is beneath it. After the paint has dried, you rub off the rubbery frisket to reveal what is beneath. It's a great technique to leave a single word white in a multicolored painted area. You can also choose to add color to that area later.

This technique can be done with a dip pen, a small pointed brush, a liner brush, or a wider brush, depending on what effects you want to create. Several brands of frisket also make a tool called a "nib" that has a fine tip or a broad tip and provides a stiffer tool for writing than a brush. I would also recommend Colour Shapers, which are silicone-tipped, brushlike tools; dried frisket just peels right off them.

You can use any acrylic paints over the frisket lettering. If you use gesso, it is much harder to remove, so it is best done as a gesso wash. Otherwise be prepared for a lot of rubbing with a frisket eraser or to use some sandpaper. Once your paint or ink is fully dry, you can rub gently with your finger or special frisket eraser to remove the masked areas. Try a prepainted surface with a bright color or start with a white surface, and you can decide to add color to your lettering later. Use lighter fluid or brush cleaner to remove the frisket from your brush before it dries, or just use a very cheap brush that you will toss. You might also find that rubbing your brush in soap before use helps. Or you could alternatively use a silicone brush that has a fine tip. Once the frisket is dry it is easy to peel it off.

Materials Needed

- alphabet or words printout
- graphite transfer paper
- ballpoint pen
- unprimed or gesso-primed watercolor paper, primed wood panel, or canvas
- acrylic paints
- tiny, cheap brushes or silicone tools
- 1" flat brush or mop brush
- Incredible White Mask Liquid Frisket
- frisket eraser or adhesive pick-up square

Optional:
- ruler
- white China Marker or wax resist stick or white-colored pencil

1

2

3
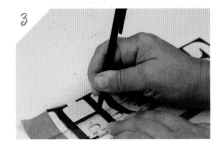

4
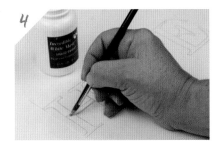

1 Use lettering you have copied or printed. Transfer onto your white surface (that is not gessoed).

2 Check to make sure transfer is working.

3 Continue transferring the word until you have completed the design.

4 Apply liquid frisket with an inexpensive brush or silicone brushtool, painting fully inside each letter.

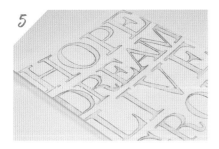

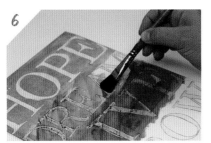

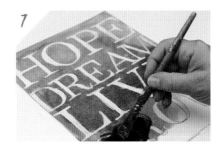

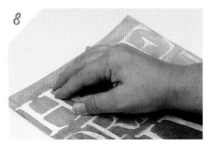

5 Continue until you have done your entire design. Let air dry.

6 Paint over the top of the dried frisket gently, allowing color wash to settle around all the letters.

7 Use multiple colors if you want, but don't allow too much paint to build up over the frisket. Let fully air dry.

8 Gently rub the edge of each frisket letter with the tips of your fingers to carefully pull off the frisket.

9 You can also use a frisket-removing eraser which will save your fingertips if you have a lot of frisket to remove.

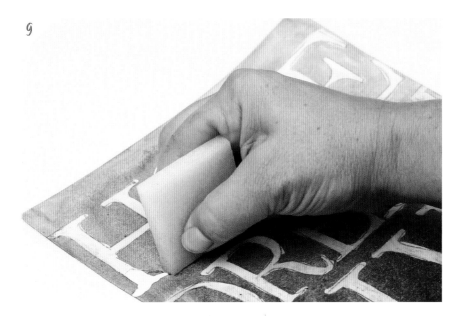

Optional: Color Wash

You can choose to add a color wash into the white letters you have revealed when the frisket was peeled off.

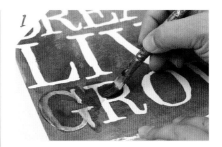

1 Once all frisket has been removed, you can paint a colorwash into your white letters if you want.

2 You can even use multiple colors for one letter for an ombré or graduated effect.

Variation: Rubber Cement Lettering

The kindergarten version of frisket is to use rubber cement to paint an area with letters, although for a little more money I think frisket is probably a better product to use with kids, since it is less volatile. You can use the brush that comes with the rubber cement, a cheap brush that you will toss afterward, or a silicone brush tool.

Do All Things with Love. Technique used: liquid masking fluid-painted letters, acrylic color washes.

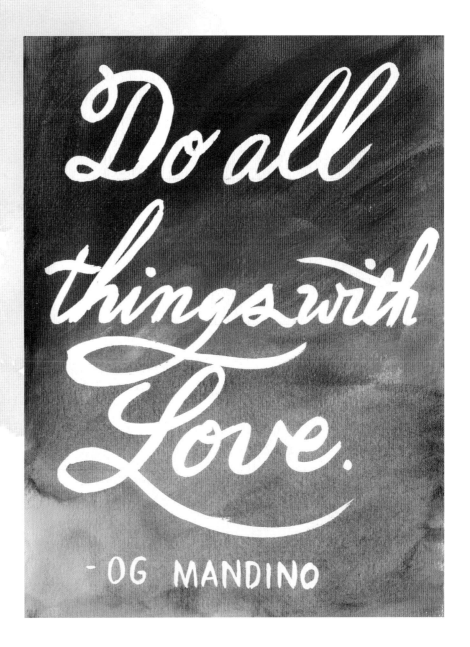

Variation: Wax Resist Lettering

You might think of this technique as something just for kids, but wax resists are a lovely way to work with lettering. You can use a white crayon, a white-colored pencil, or a white China Marker (or wax resist stick) to create letters on unprimed paper, then paint over the lettering. Any waxlike writing tool creates a resist. As long as you are working with color washes, when you try to paint over any lettering you have created, the wax letters will stay put. It is a subtle but nice technique. Be careful not to use the paint full strength or you will cover over the lettering; often, using a paper towel or soft cloth, you can wipe off the letters as well to keep their integrity. Typically this works best directly on paper, rather than on a gesso-primed surface.

Paint over white China Marker writing.

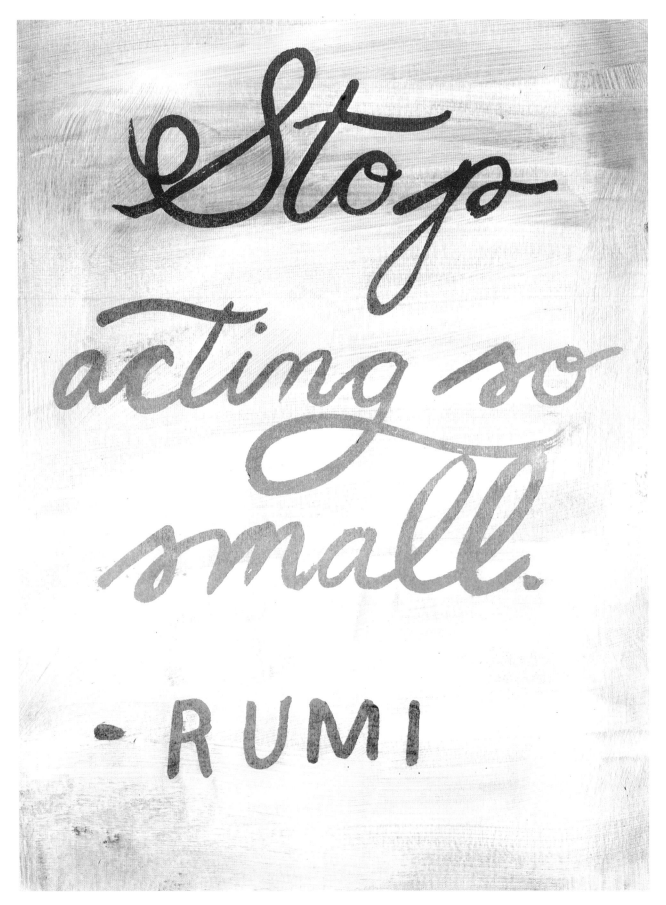

Stop Acting So Small. **Techniques used: multicolored painted background, liquid masking fluid letters, white gesso (reverse frisket).**

REVEALED

Reverse Frisket Lettering

For some really fancy larger lettering, you can start with a multicolored painted background, paint your frisket letters, then paint over the top with a solid color. This top layer is a bit harder to work with, especially if you use white or black gesso; it is much harder to remove the frisket underneath it since the plastic quality of the paint is protecting the frisket. Start with a frisket-removing eraser, but if you have trouble, you can certainly use sandpaper to remove both the paint and the frisket.

Materials Needed

- painted abstract artwork (multicolored)
- white gesso
- 1" flat brush or mop brush
- Incredible White Mask liquid frisket
- frisket applicator tool or pointed brush
- frisket eraser

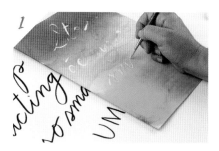

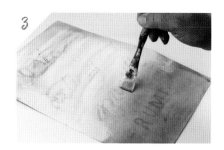

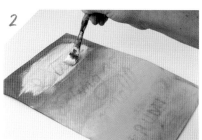

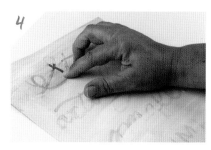

1 Do big, thick writing with liquid masking fluid. Let air dry.

2 Apply a think wash of white gesso over your frisket letters.

3 Optional: Continue to apply white gesso wash over your entire piece. Let dry.

4 Rub off the frisket, using your fingers or frisket eraser, or if there is too much gesso, try sandpaper on tough spots.

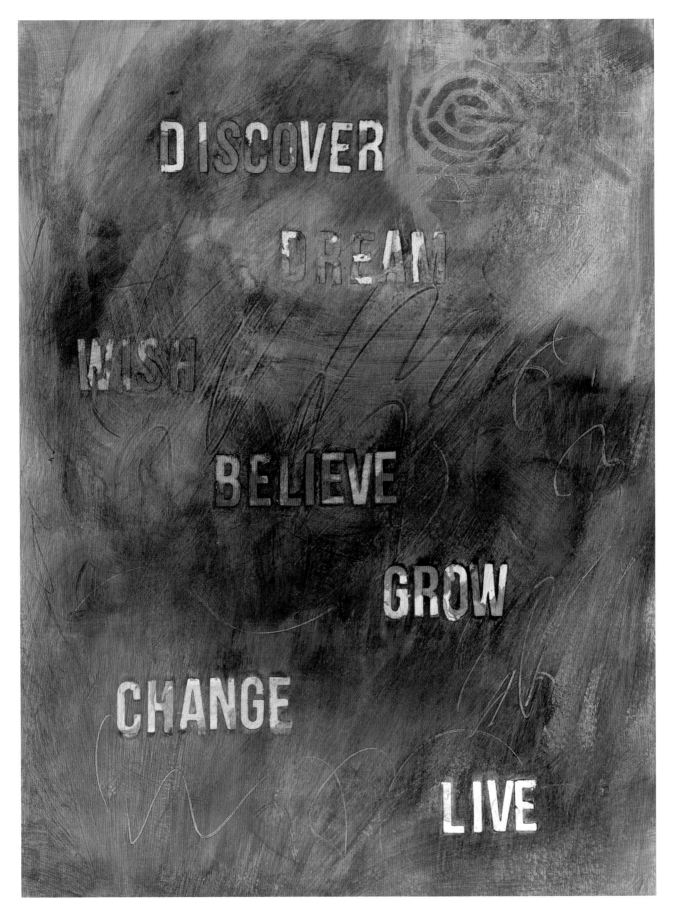

Discover & Dream. **Techniques used: stick-on lettering as mask, acrylic painting and gesso and wet paint scribing, reverse stencil, color wash.**

Stick-On Masked Letters

While stick-on lettering itself might not seem that artistic, the shape of the letters is often all you need to have some nice, simple words or sentences without having to hand letter or stamp. By using stick-on letters first, then painting around them, you can create some wonderful projects. When it is dry, you can carefully peel off the lettering to reveal the background and, optionally, add a color wash to those letters. If you work on bare paper, like I did for this exercise, there is a little peeling effect that happens since the sticker may or may not lift up some paper. It really depends on the stickiness of the letters, how well they were adhered, and how long you leave them on your surface. A primed surface works better with a clean pull. You can also work with a colored surface first. The nice thing is that it doesn't matter what color your stickers are. They can be foam, plastic, or even sparkle lettering, as long as the edges have a nice, clean seal with the surface. If you are looking for small lettering, try scrapbooking resources. If you are looking for larger letters, shop your local hardware store, where they have larger, stick-on letters for garage sale signs.

Materials Needed

- graphite pencil and eraser or watersoluble pencil
- watercolor paper or canvas, etc., primed with white gesso
- stick-on or rub-on alphabet letters
- white gesso
- 1" flat or mop brush
- acrylic paints
- paper towels
- baby wipes
- X-Acto knife
- embossing tool
- scribing tools (toothpick, tip of brush, etc.)

Optional:

- brayer
- tweezers
- pattern/design stencils
- white gesso
- makeup wedges

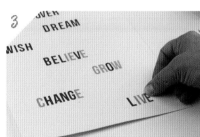

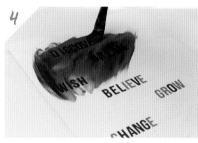

1 Draw rule lines on your substrate and begin to stick on your lettering. Use a burnishing tool, like the end of a paint brush, bone folder, or embossing tool.

2 You can also use your fingers to place your lettering.

3 Continue all the way to the bottom of your project. You can use any color of letters since they will be peeled off.

4 Add paint wash over the top.

5 Spread around the paint with a brush or soft cloth.

6 Apply a second color wash if you like.

7 Apply some gesso wash and do some scribing if desired, but not too thick over the letters. Let dry.

8 Apply more paint washes if you like. Let dry.

9 Carefully peel off the letters. Do this slowly in case they take off more paint than you want. You can cut the edge of the letter gently with an X-Acto knife to remove it from the background.

10 Continue to carefully peel off letters.

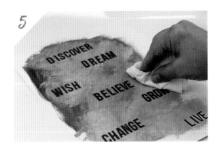

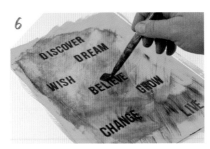

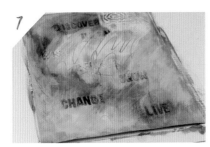

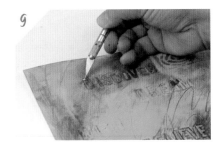

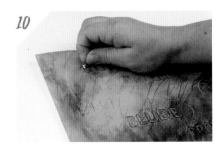

11 When you have finished peeling letters you can stop or continue with other layers, depending on how complicated you want your piece to be.

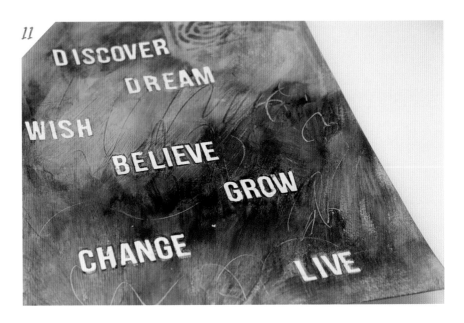

Optional: Color Wash

Add color wash after peeling away the stick-on letters.

1 **You can add a color wash to the insides of your revealed letters.**

2 **Carefully wipe off color if it gets too dark.**

3 **Add some different colors if you like that contrast with your background painting.**

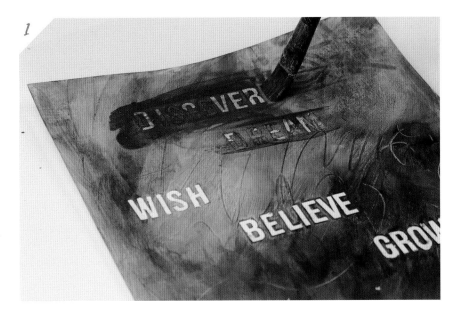

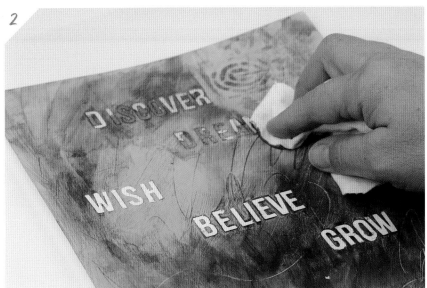

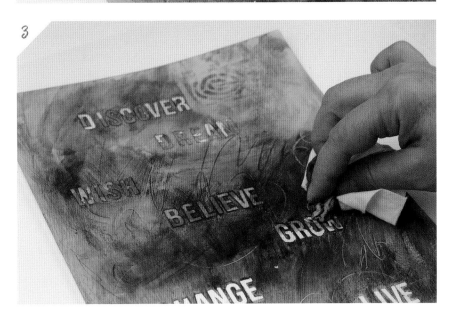

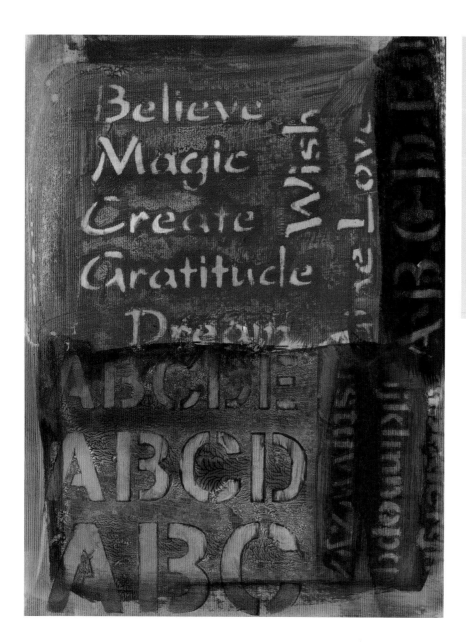

Materials Needed

- painted background artwork
- acrylic paints
- 1" flat brush or mop brush
- paper towels
- baby wipes
- word or quote stencils

Optional:

- heat gun

Reverse Stenciled Lettering

You can also use a stencil to remove paint from an area. It is a messier technique, since you are working with a whole surface that is wet and dropping your stencil right into it and then removing the paint through the stencil openings. If you are working with a plastic or acetate stencil, the plastic pulls up on the wet paint or gesso in an interesting, almost organic pattern. Allowing the paint to dry a little more before applying the stencil will change the result, but might require baby wipes to wipe away the areas inside the stencil. I recommend working with a gesso-primed surface; bare paper will not work as well for this technique since the paper immediately begins to absorb paint.

Believe in Magic. **Techniques used: reverse stenciling with wet paint, color washes.**

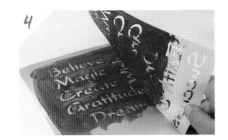

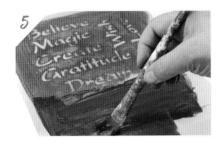

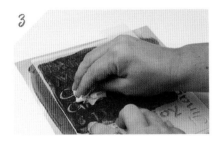

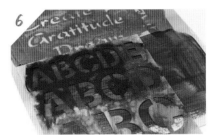

1 Create a painted background with a bright color (in this case, yellow). Let it dry. Apply fresh paint in a contrasting color (in this case, I used red).

2 While paint is still wet, carefully set a stencil over the top (full-word stencils work best for this technique).

3 Quickly, while holding the stencil tightly so it doesn't move, wipe out the centers of the stencil word with a dry paper towel.

4 Carefully lift off the stencil. Let dry or use a heat gun.

5 Apply more paint in another contrasting color.

6 Quickly set down a new dry stencil into that wet paint carefully.

7 Hold the stencil tight while you wipe away the center portions of this stencil with a dry paper towel. If your paint is drying too fast or you have waited too long, use a baby wipe to remove the centers of the stencil design.

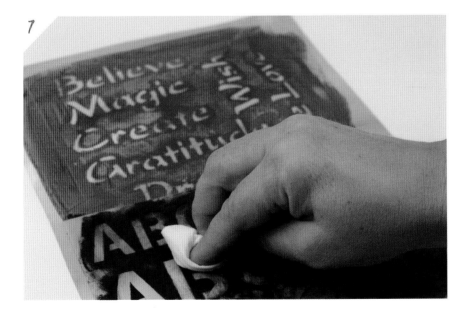

Optional: Add Color Wash

When any areas of stenciling with a light colored or white center are dry, you can add a color wash.

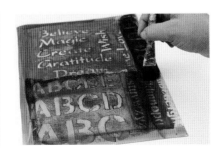

Apply a color wash to dry, light-colored areas of dry stenciled designs with a brush or cloth.

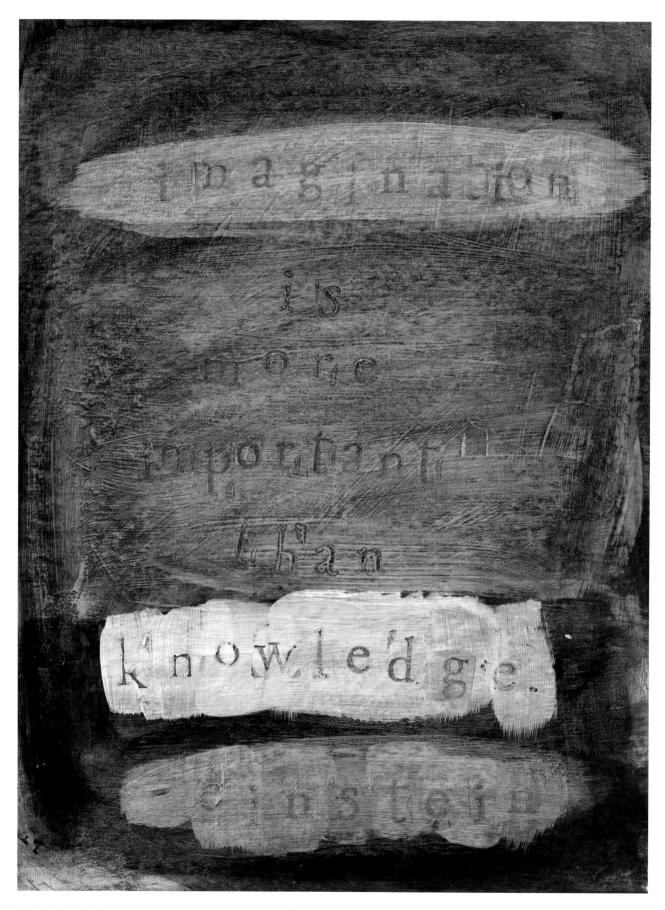

Imagination. **Techniques used: debossed wet gesso with
stamps, gesso washes, color washes.**

Blind Debossed Gesso Letters

This is a simple technique that is hard to see visually because it is usually white on white, but that is what makes it magical when you add color later. For these samples, I added a couple of drops of fluid turquoise paint to gesso to make tinted gesso. In printing terminology, a blind emboss is when the paper is run through a press with raised letters without any ink. A blind deboss is a depression into the paper; in this case it is into the wet gesso. I also like to refer to it as "stamping off," because one of my favorite things to do is to have two projects side by side, paint wet gesso on the project on the left, stamp into it, and then use the same stamp on the project on the right. It is a great use of paint or gesso, since nothing is wasted. You can choose to work in this manner or simply deboss the gesso and then wipe off your stamp immediately. The thicker and drier the gesso, the better an imprint you will achieve.

Materials Needed

- painted background art
- white gesso
- acrylic paints
- alphabet or word rubber stamps
- baby wipes or stamp cleaner
- paper towels
- 1" flat brush or mop brush

Optional:

- nailbrush or toothbrush
- letterpress blocks
- embossing folder
- rubber stamp designs

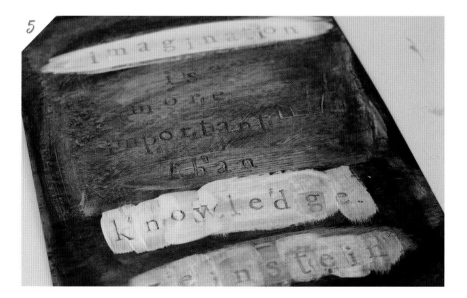

1 Paint an area with wet gesso (it can be white; for photography purposes I have used tinted gesso).

2 While gesso is wet, stamp into it (deboss) with a rubber stamp.

3 Add more gesso as you work your way down the page so that the gesso stays wet, and do more debossing as you go. Let fully dry.

4 Paint over the debossed letters with another color of paint to reveal the letters.

5 White gesso over a darker paint will reveal lettering when you stamp.

Handy Tip:
Cleaning Your Stamps

Wiping off a rubber stamp immediately after stamping into gesso will keep its integrity. I often use a baby wipe, but rubber stamps that are complex might end up with gesso in the center of the design. I like to keep a toothbrush or small nailbrush and a little dish of water handy, that way I can quickly brush off a rubber stamp that has been dipped into gesso or paint, and then dry it off with a paper towel so it is ready to be used again.

Clean off rubber stamps immediately with a baby wipe. Use a wet nailbrush or toothbrush to clean if you have a complex stamp. Then dry the stamp before reuse.

Optional: Add Color Wash

You can add one simple layer of debossing or add another layer on top; in this case I added another white gesso layer and color wash.

Any lighter areas of your painting can have an added color wash or metallic wash when dried for some interesting results.

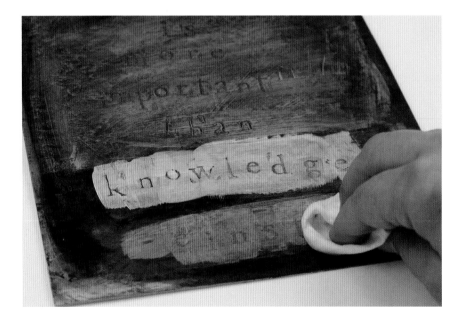

Variation: Letterpress Block Debossed Letters

Wooden blocks have nice crisp edges that are actually better than rubber stamps for debossing techniques. If you can find any letterpress blocks, they work really well. You just have to get used to spelling out words backward!

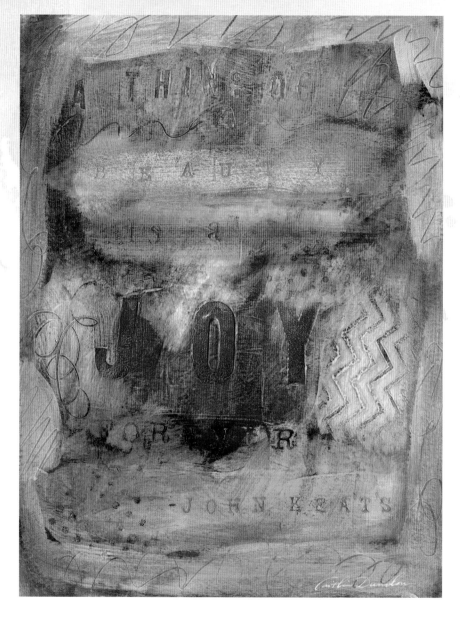

A Thing of Beauty. Techniques used: blind stamping (debossing) with rubber stamps, plastic embossing folders, blind debossing with letterpress blocks, scribing into gesso, color washes.

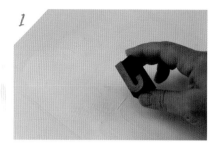

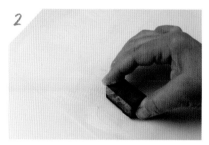

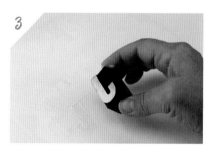

1 Paint a small area with white gesso and prepare to stamp with your letterpress block. Note that the letterpress block will appear backward when you look at it, but will print correctly on your surface.

2 Press the letterpress block into the wet gesso.

3 Continue with other letters. Wipe off letterpress with a baby wipe or brush clean with a nailbrush if necessary, and dry off after each letter.

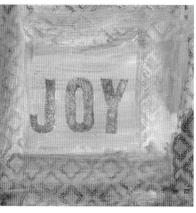

Joy. Techniques used: letterpress debossing into wet gesso, plastic embossing folder debossed into wet gesso, color washes.

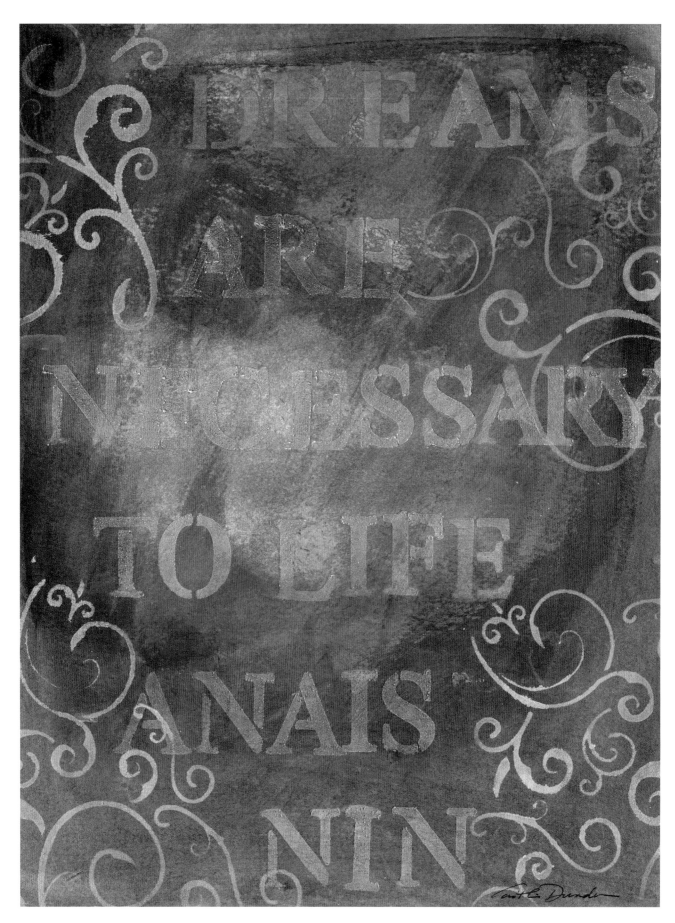

Dreams Are Necessary. **Techniques used: blind resist, acrylic color washes, gesso stenciling over watercolor paper.**

Blind Stenciled Gesso Letters

Gesso applied to a surface, especially bare paper, creates a barrier or resist for paint in the same way the clear embossed stamping does. It is another magical technique to take bare white paper, stencil lettering on it in white gesso, let dry, and then add color and see your lettering appear. I like to use this technique to create a background that is more subtle, building color over your lettering. You can also use clear gesso or soft gel for this process, but white is easier to see. If you have trouble seeing your white gesso on white paper, try lightly tinting the gesso a pale yellow or light blue.

Materials Needed

- unprimed watercolor paper or primed paper/canvas or wood panel

- white gesso

- paper plate or palette

- makeup wedges

- acrylic paints

- 1" flat or mop brush

- alphabet or word stencils

- baby wipes

- paper towels

Optional:

- heat gun

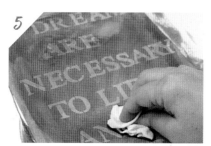

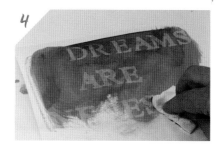

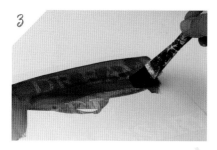

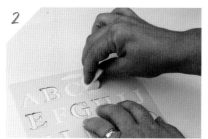

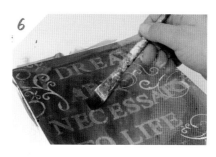

1 Apply white gesso paint to a paper plate or palette paper in a flat (not goopy) manner.

2 Using a makeup wedge or brush, apply gesso through stencil onto unprimed watercolor paper. Do a whole word. Or work slowly and do one letter, let it dry, and repeat. Let dry.

3 Apply a color wash to reveal your magic lettering.

4 Buff around the paint so it is not too heavy in any one area and to help reveal the lettering.

5 Continue to move color around and lift it off the letters.

6 Apply more colors if desired.

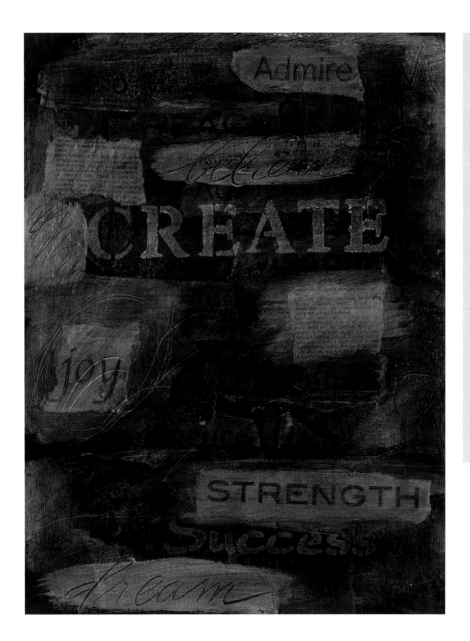

Materials Needed

- painted background artwork
- words/phrases to collage
- acrylic soft gel
- 1/2" flat brush, 1" flat brush or mop brush
- white gesso
- acrylic paints
- scribing tools (toothpick, etc.)
- sandpaper
- alphabet stencils, stamps

Optional:

- old novel pages/newsprint or other ephemera to collage
- heat gun

Deconstructed Letters

This is a great technique to allow yourself to play and create and to see what magic happens. Create a background with a lot of applied techniques that we have already covered, like collaged, stamped, and stenciled letters. Add layers of gesso and paint washes over the top and then have fun using a damp cloth to remove some paint immediately after you've painted it, revealing some but not all of the lettering. You can also allow the paint or gesso to dry and then use sandpaper in a technique called sanding back to remove the paint and discover what's underneath. After sanding, I like to apply a color wash in a nice light color like Golden's Quinacridone Nickel Azo Gold. Or, I work with more of an antique look by using a darker color such as Golden's Burnt Umber. Make sure you have a damp paper towel ready to remove paint before it dries; that way it just sinks into the cracks you sanded and doesn't completely cover up all of your lettering. You can work in layer after layer this way, perhaps creating artwork where the lettering might not be as readable, but it's beautiful and mysterious.

Create Strength. **Techniques used: printed and found paper collage, gesso washes, color washes, sanding back, stenciled gesso, scribing into wet paint.**

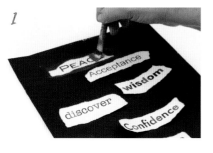

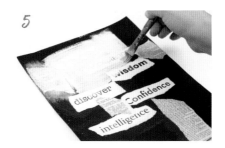

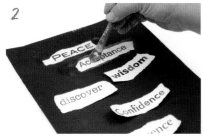

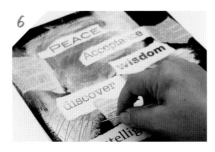

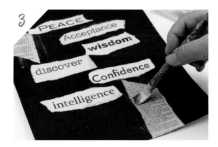

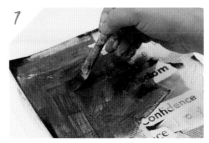

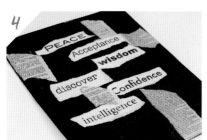

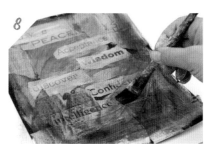

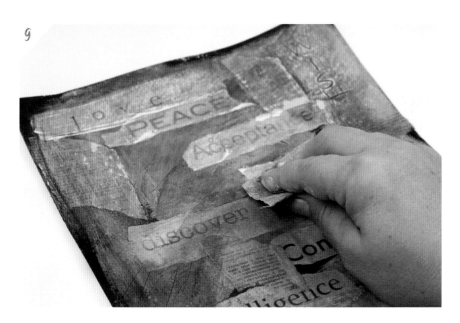

1 Start with a black gesso or painted color background that is dry. Attach printed lettering with acrylic soft gel.

2 Continue with more collage, brushing over the tops of all papers.

3 Continue to collage other scraps of decorative or found paper with or without text.

4 Continue until you have covered about half or a little less of your surface. Let dry.

5 Apply thin white gesso wash. Buff or lift off areas where you have applied gesso too heavily, if necessary.

6 Apply texture, write words, or scribble into the wet gesso as desired. Let dry.

7 Apply color wash, dark in some areas.

8 Apply color wash, lighter in some areas. Apply or lift off with a paper towel.

9 Use sanding and more color washing and/or stenciled layers to create your final look.

Enjoy

Live

Laugh

Love

Dream

Believe

Explore

Learn

Grow

Succeed

Create

Wish

Caitlin Dundon

Handwritten Lettering and Calligraphy

Creating letters by hand, whether you're using a traditional tool, or some other household or handmade tool is a process that creates some unique results. The ability of an artist to make marks with pens, a stylus, or other tools is what sets us apart from computer-generated art. Everyone's handwriting is unique, so even if you are imitating someone else's handwriting, there is still uniqueness to each individual that comes through in different pressure applied, and different length of stroke and different angles and energy used.

The nice thing about hand lettering is that we can also use other techniques like collage or even rubber stamping to incorporate our own handwritten script, allowing for layout flexibility and time to check and correct typos too. By working with a separate piece of paper with our handwriting, we can relax from any stress that might exist about making a mistake on our final artwork. Scanners and copier machines will help transform that handwriting into multiple copies we can collage with or just paint into. These days you can even create a custom rubber stamp of your own handwriting, so the possibilities become almost endless.

When we start a conversation about handwriting, there is sometimes a fine line between actual writing and the beginning of mark making and what is readable as text. Modern calligraphers and lettering artists have been pushing the boundaries in spectacular ways, creating some pieces that are full of mark making, color, and texture—all with a basis founded in letters. So let yourself explore everything handwritten and allow yourself to play as you create some beautiful mixed media art, using some of the same techniques we have already learned in this book, but also adding to it with more pens, markers, and calligraphy tools.

Color Quilt: Enjoy, Live, Laugh. **Techniques used: acrylic paint, sanding back, color washes, acrylic glazing, pointed pen calligraphy in white acrylic ink.**

HANDWRITTEN

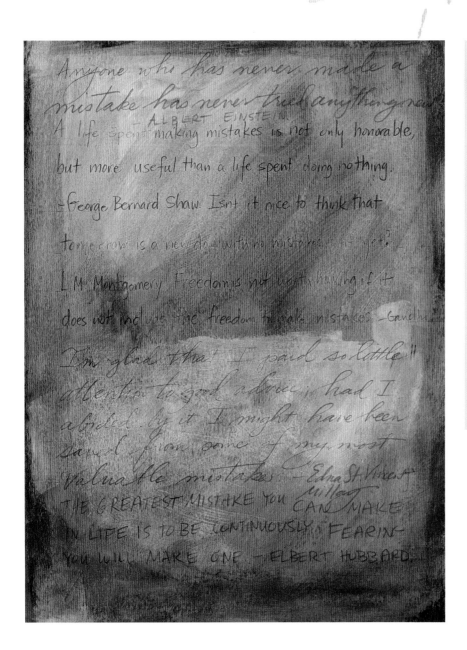

Materials Needed

- graphite pencils
- water-soluble pencil (light blue or other color)
- white gesso-primed watercolor paper, canvas, or wood panel
- white gesso
- acrylic paints
- 1" flat brush or mop brush
- paper towel
- baby wipe

Optional:

- heat gun

Try Anything New. Techniques used: graphite script, gesso, color washes.

Pencil Lettering

There's a nice softness that pencil adds to a piece of art that makes it completely different from pen and ink or printed lettering. Even slightly obscured pencil lettering has a lovely antique look to it. Your classic No. 2 pencil from elementary school is just fine for simple hand-drawn letters, but you might want to invest in an artist-grade graphite pencil in 2B or 4B weight to get a little darker quality of graphite. Harder pencils like an H or 2H can be used to spread and fill any pencil shading you've already created.

The graphite in pencils is waterproof and somewhat indelible—think about the longevity of some of your elementary school scribblings that your parents have kept in that scrapbook or shoebox all these years. Graphite does have a tendency to smear a little, depending on the thickness of your pencil point. You can use a spray fixative if you like to protect your pencil layer, but typically I just dive in and let the media mix as they will. You can also use the graphite transfer paper that we used on page 21 to trace some larger letters or a font, but then you can augment with hand lettered sketching or highlighting using shading.

Even the most basic looking printing with your own hand can be just the thing to layer into your mixed media piece, whether it's handwritten directly onto your substrate or used as a collage piece. If you have not printed or done any cursive lately, take a refresher course in cursive or printing or simply practice your freehand curves, lines, and loops. The more you practice, no matter what your age, your handwriting will improve.

1 Draw water-soluble guidelines on a white gessoed surface.

2 Write freehand with a graphite pencil. Try some different writing styles and sizes.

3 Erase any mistakes when you make them. Continue to fill the page as you like.

4 Apply color wash.

5 Apply another color wash.

6 Blend color washes with soft, damp cloth.

7 Lift off any color that is too dark and obscures writing too much.

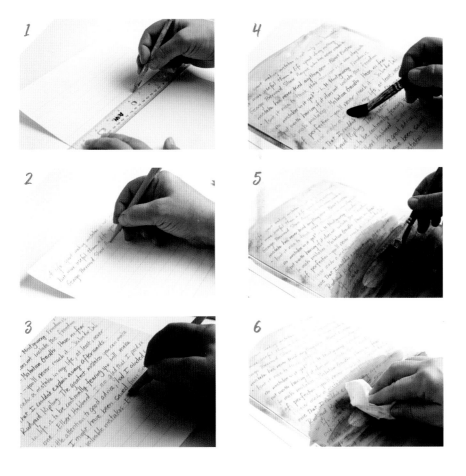

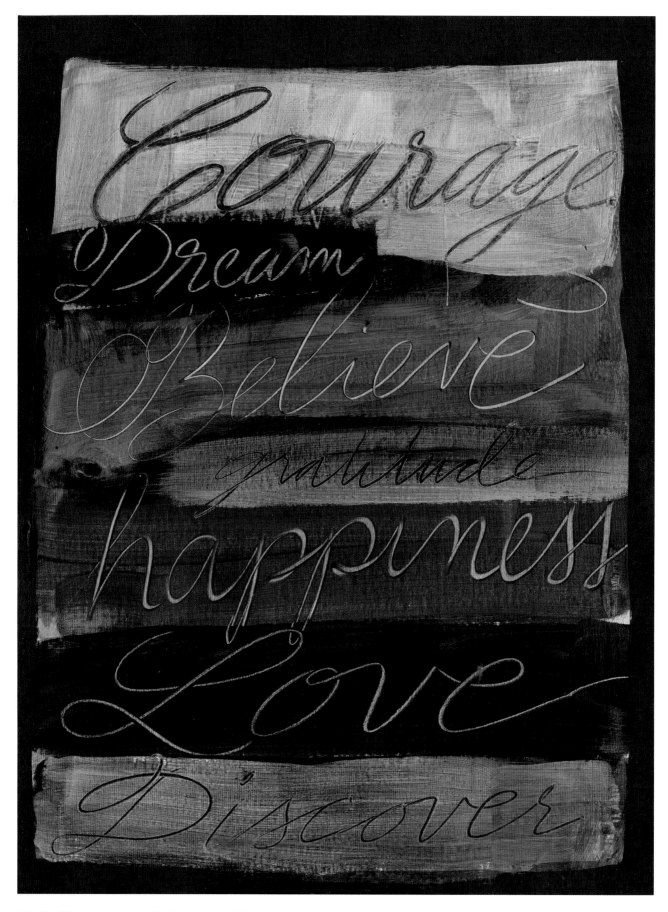

Words of Encouragement. **Techniques used: black gesso,
scribing into wet paint, scribing into wet gesso, color washes.**

Scribed Lettering

Inscribing or scribing (also called sgraffito) into wet paint can be a wonderful way to get some texture and text into a painting. Depending on what tool you use, it can be readable or unreadable. By working with a bright or dark background and then applying an opposite color, you can scribe and reveal the color in the background. This is a lovely effect for lines, handwriting, and general mark making. I enjoy using a calligraphy pen (without ink) that I just write straight into wet paint with. Wipe the end of whatever tool you are using as you write to clear it of built-up paint. A toothpick is one of my favorite tools for mark making like this. You can also use a bamboo skewer, the end of a small brush, a sharpened pencil, or a ballpoint pen that has run out of ink. If you find you need more time to write before your paint dries, try using an acrylic, slow-drying, medium or open paints since they will give you longer working time before your acrylic paint dries.

<div>

Materials Needed

- painted artwork
- white gesso
- black gesso
- acrylic paints
- 1" flat brush or mop brush
- paper towels
- scribing tools (toothpick, paintbrush tip, silicone tools, etc.)

Optional:

- heat gun
- acrylic soft gel
- metallic or interference acrylic paint
- patterned rubber stamp

</div>

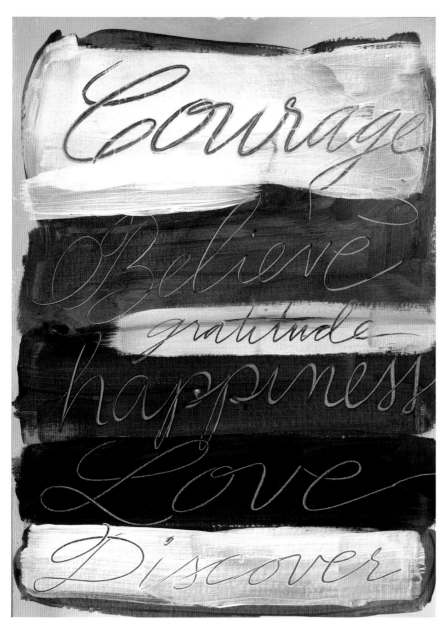

Words of Encouragement (in progress). Techniques used:
black gesso, scribing into wet paint, scribing into wet gesso.

The Only Journey. Techniques used: scribing with pencil into wet gesso, color washes.

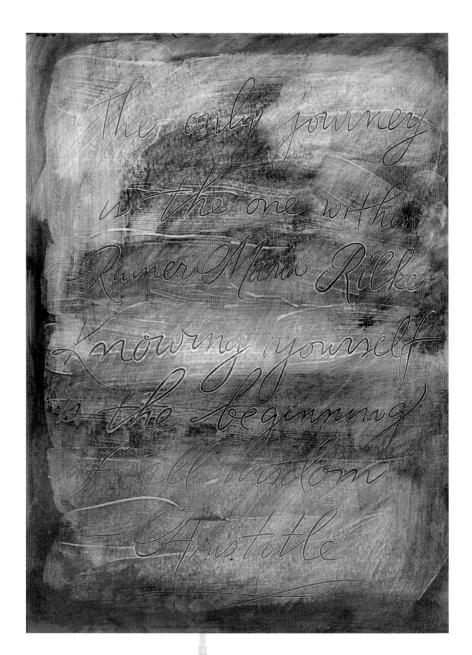

Mistakes (close-up). Techniques used: black gesso, gesso scribing into wet (white) gesso, acrylic color wash.

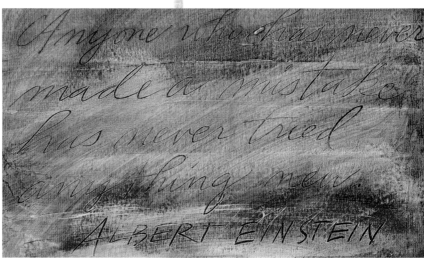

Variation: Scribing into Gel

Any tool like a pencil, ballpoint pen, tip of a paintbrush, or an embossing tool can be used to make textural marking into acrylic gel. I like using soft gel, but you can experiment with heavy levels of gel to see what one you like to write into. Try experimenting with different depths. I find that shallow ones are better for pressing stamps or objects into the gel. The thicker the gel, the longer it will take to dry. Once it is dry, you can also add other color wash or even metallic paint for interesting effects. Depending on how much gel you use, your piece could become very plastic looking, but sometimes effects can be very ethereal. You can also work with tinted gel and not use any color washes.

Believe. Techniques used: acrylic painting, scribing into wet gel, stamping into wet gel, interference gold wash.

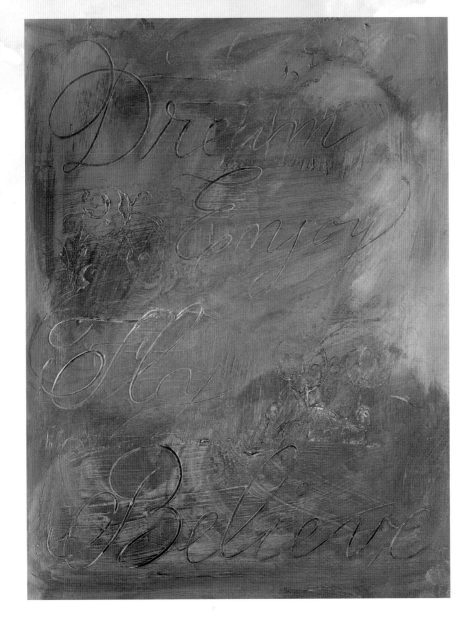

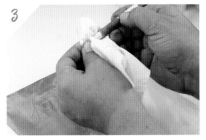

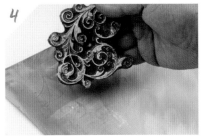

1 Use a painted or gesso-primed background. Apply soft gel with brush or palette knife.

2 Use a tool to write your script.

3 Wipe off your tool as you work; a cleaner tool will pick up more gel.

4 Try rubber stamping too. Immediately rinse off stamp with soapy water and scrubbing brush, then dry off.

5 Continue scribing; scrape off or paint over an area with more gel before it dries if you don't like your design. Optional: When dry, you can add a metallic or interference paint wash.

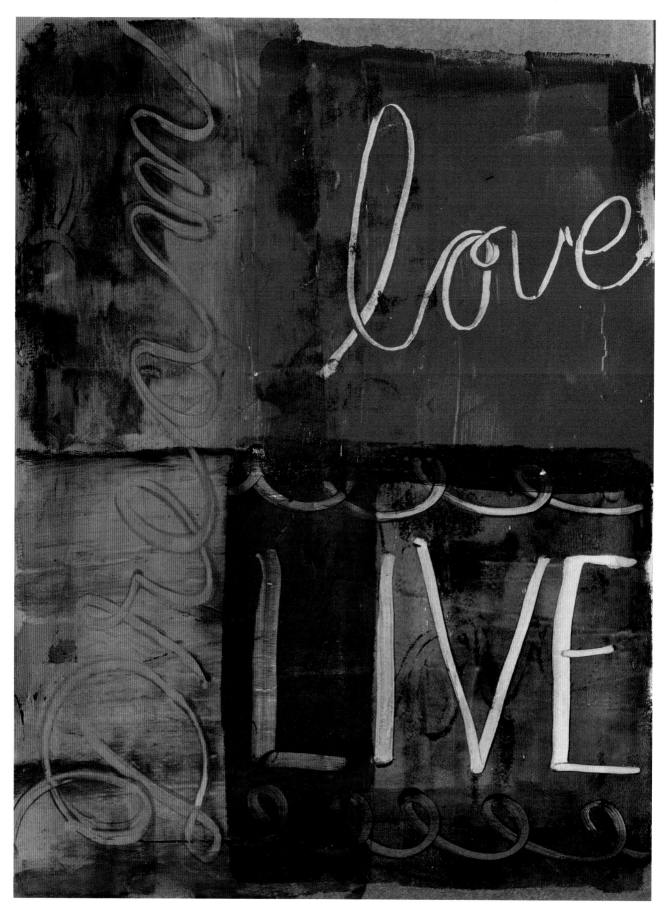

Dream, Love, Live. **Techniques used: gel printing with acrylic paint, color washes.**

Gel Plate Cursive Lettering

We already addressed fonts created by hand with gel plates, but cursive is fun to see in print too. Cursive on gel plates is a little trickier since we have to essentially write backward. However, if you start with simple big letters written forward first on tracing paper, you can flip it over and write it backward on your plate while removing paint. I still like working left to right, but you might try working right to left instead. Do whatever is most comfortable. Since you might be switching to a clean cotton swab, you can also write a cursive word letter by letter for better control.

Materials Needed

- cursive word reversed or lettering on tracing paper (flipped to reverse side)

- gel printing plate

- brayer

- acrylic paints (fluid or heavy body used with water)

- cotton swabs or double applicators (pointed tip)

- printing papers (watercolor or deli papers)

- baby wipes or hand sanitizer

- mini mister or small spray bottle

- paper towels

Optional:

- heat gun

- 1" brush or mop brush

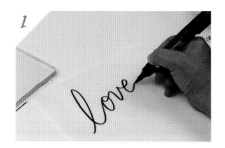

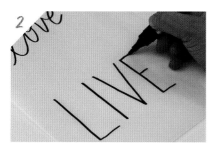

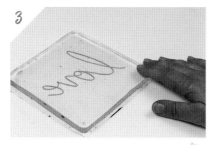

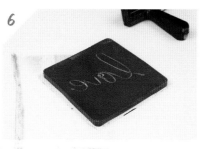

1 Handwrite a cursive word onto a piece of tracing paper the size of your gel printing plate.

2 You can also do a simple, printed design too, on another sheet of tracing paper.

3 Flip your design over so it is backward and place it under the gel plate.

4 Apply open paint or fluid paint that is fairly transparent to the surface of your gel plate.

5 Use a clean cotton swab or another soft tool, or use a tool wrapped with a cloth to trace your letters.

6 Lift off the whole word in parts that appear connected or write it completely backward all in one fell swoop.

7

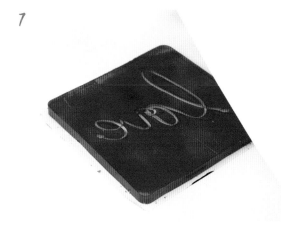

10

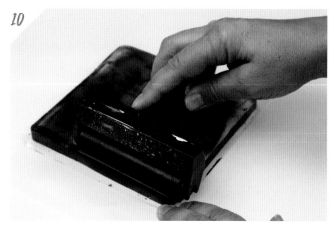

8

11

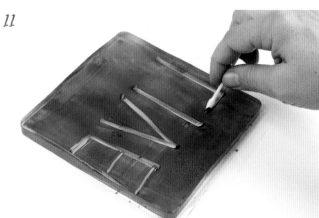

9

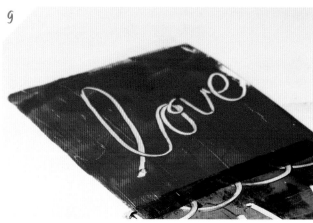

12

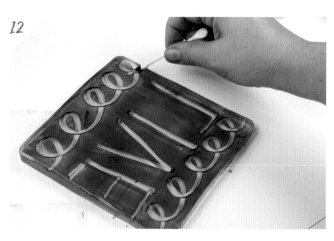

7 **Grab your paper and place it as straight and centered as you can over your plate.**

8 **Burnish the back of the paper quickly with the palm of your hand.**

9 **Pull off your paper to reveal your print. Pull a ghost print if your plate is not clean.**

10 **Put a different design backward under your plate. Apply a different color to your plate (cleaning off previous color is optional).**

11 **Use a clean cotton swab or other soft, absorbent tool to trace your letters and lift off your paint.**

12 **Optional: Add some fun swirls to practice your cursive. Apply paper and rub gently with your palm.**

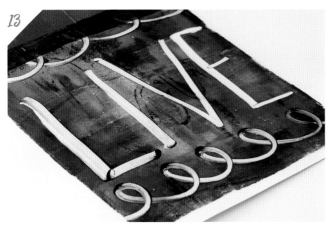

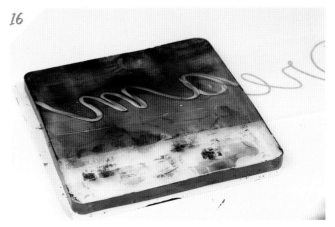

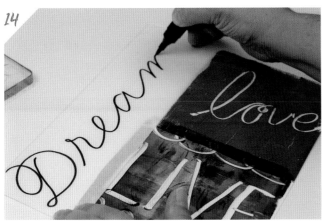

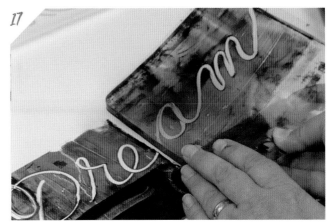

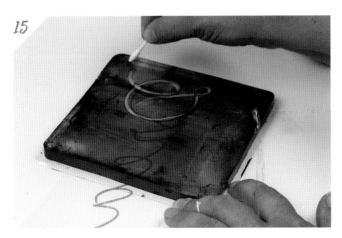

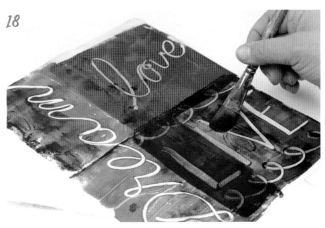

13 Reveal your pulled print.

14 Write another word. If your word is longer than your plate, you will need to do two passes.

15 Place the left half of the design under your plate first, roll on your paint color, and lift off with your cotton swab. Pull your print, leaving room to the right of it for the right-hand side of your word.

16 Use the other half of your design to write the other half of your word in a fresh coating of paint.

17 To line up the second half of your print onto your paper, it might be easier to carefully pick up your gel plate and turn it upside down so you can see what you are doing. Place the gel plate down onto your paper, then flip the paper over to burnish the back with your palm. Pull your print. Let dry.

18 Option: Add a color wash to areas of the dried print.

Every child is an artist. The problem is how to remain an artist when you grow up. ~Pablo Picasso. Only through art can we emerge from ourselves and know what another person sees ~ Marcel Proust. The object of art is to give life shape. ~Jean Anouilh. Life beats down and crushes the soul and art reminds you that you have one. ~Stella Adler. Art enables us to find ourselves and lose ourselves at the same time ~Thomas Merton. Art is not a thing it's a way. ~Elbert Hubbard. Creativity takes courage. Matisse.

Caitlin Dundon

The Art of Life. Techniques used: acrylic paint washes, stencils, reverse stencil, scribing into wet gesso, black high flow calligraphy with pointed pen.

Dip Pen Calligraphy

Not everyone can pick up pen and ink and be a great calligrapher, but it doesn't mean you shouldn't give it a try. I think even simple handwriting that is your own—whether it's block printing or the cursive you barely remember from elementary school—looks absolutely fantastic in pen and ink. When you have created your own artwork and can add your own handwritten touch, it will make it that much more of a personal creation. Modern calligraphy tools include a wide range of nibs, holders, and inks. Some are more difficult than others to use without a lot of training, but with the popularity of calligraphy and handwriting in general these days, there are many online calligraphy classes. You might find some local classes in your neighborhood too.

Many inks, even ones that are labeled as waterproof, might still react or smear with overpainting, or brushed gels or varnishes. So if you plan on doing your own calligraphy, think about doing it as the last step on a piece or do tests beforehand. Remember you can also write your own calligraphy, then copy it and collage it as a way to incorporate it into your art.

Materials Needed

- painted artwork
- sandpaper (fine grade/black)
- water-soluble pencil
- ruler
- dip pen (NIKKO G pointed pen nib, straight penholder)
- Golden high flow (carbon black or other color)
- water
- paper towel

Optional for variations:

- Sumi ink or India ink
- broad nib calligraphy pen
- Daler Rowney FW White acrylic ink

Handy Tip: Spelling Errors

If you find a spelling error or mistake in your writing after the acrylic ink has fully dried, you can remove the ink by using nail polish remover or paint thinner on a cotton ball or swab. Sand it a little and reapply gesso and paint to match, and then you can rewrite over that area.

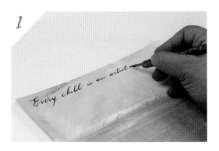

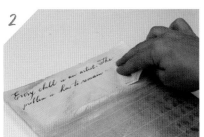

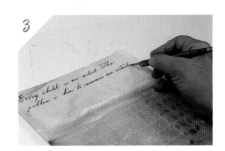

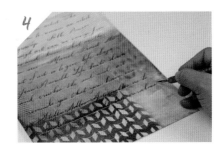

1 If you are working with permanent or high flow ink, draw guidelines on your paper with a water-based pencil. Start your writing. Wipe off the tip of of your pencil occasionally with a paper towel dipped lightly in water to keep the ink flowing nicely.

2 If you make a mistake, wipe it off immediately with a slightly damp cloth.

3 Make sure the area is dry, then redo the word or phrase.

4 Continue to the end of your project, being careful not to smudge areas that have not dried.

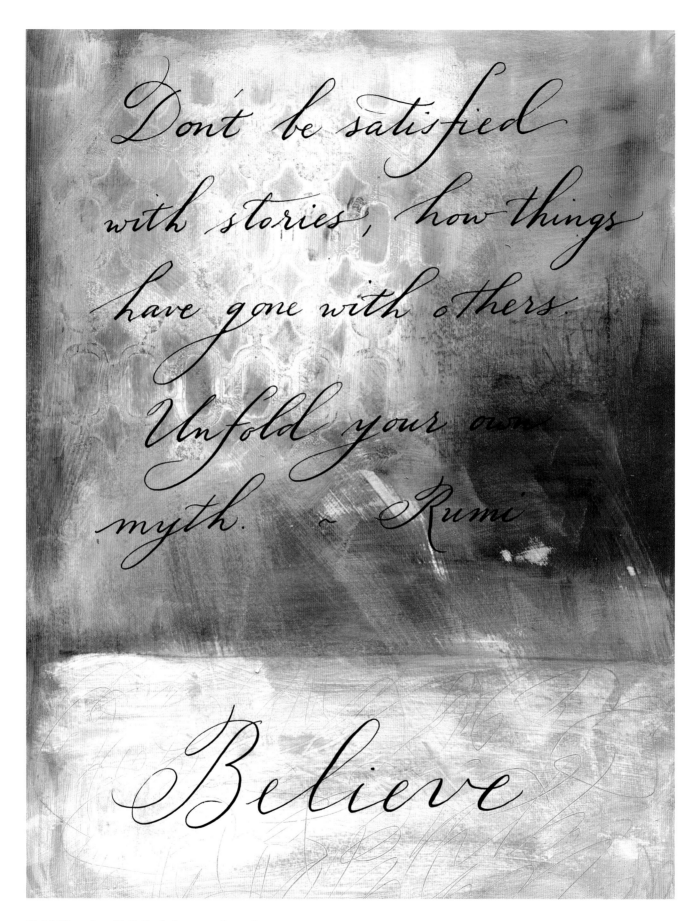

Unfold Your Own Myth. Techniques used: acrylic on paper,
reverse stenciling, scribing into wet gesso (mark making), high
flow calligraphy with pointed pen.

In Focus: Inks

You can use any ink that you like if you are working on the top of your artwork. But if you use paint, matte medium, collage gel, or any varnish as a top coat over your writing, you will need to test to make sure your ink is waterproof. It is very disappointing to work on some beautiful lettering and brush over it with a color wash only to find your writing starts to smear. I recommend testing all inks, even if they are labeled waterproof. Also, keep in mind that if you use ink that is not waterproof, you cannot draw guidelines with a water-soluble pencil!

For black script (or other colors), I recommend Golden brand high flow, which is basically a more liquid version of the same paint colors available in their fluid and heavy body acrylic line. It has a slightly elastic quality that takes a little getting used to, but it works with dip pens as well as brushes; it is completely permanent when dry and comes in all the same color selections as Golden acrylics. If you are not planning on using any paint, collage gel, or varnishes on a piece, I recommend Moon Palace Sumi Ink as it is a really nice black and flows easily with pointed pens, broad nib pens, and brushes. India ink is also quite nice and it dries to a shinier finish like the acrylic ink.

For white script, I love Daler Rowney's FW white acrylic ink; it is more opaque than Golden high flow white and is completely permanent when dry. Acrylic inks also come in a variety of fantastic colors and several metallic versions. I do recommend that after some time has passed, you might need to add a little water (a drop or two) to your acrylic ink bottle to make if flow better, as acrylic ink does start to dry out even if you close the bottle tightly after each use. Remember to clean your nibs thoroughly with pen cleaner, flush with water, or use a baby wipe and dry thoroughly to avoid rust.

Handy Tips: Using Pointed Pens

Pointed pens take a little getting used to, since they have sharp tips that easily get caught on your paper or brushed paint edge. I recommend sanding your surface with 400- or 600-grit fine sandpaper (it is usually black in color). If you lose some color, add a color wash back over your piece. I like to practice using Canson Marker paper that is nice and smooth. When working with upstrokes, have a really light hand, like you are writing on a balloon. When you are doing a downstroke, apply a little pressure to make a thicker line. It becomes kind of a press-and-release bouncy stroke. If you find your tip is scratchy or spraying ink or getting stuck, you are pressing when you should not be pressing. It also helps to think of all your movement coming from your elbow, not your fingers. Let the pen dance across the page. If you cannot master cursive, just try block printing and use the pointed pen for drawing and outlining fonts or try brush cursive instead.

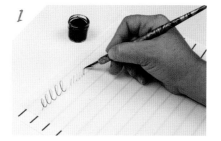

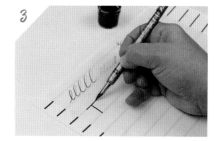

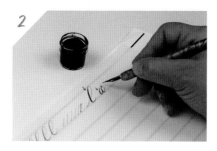

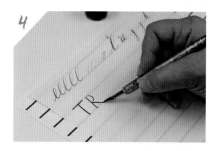

1 Dip pen into ink and practice writing your words or quotations on separate paper. Loops should be light on upstroke, slight pressure on downstroke.

2 Practice your cursive alphabet letters.

3 For block lettering you can move the pen left to right for a light stroke or physically turn the pen sideways to pull a stroke from left to right. Or, you can rotate your paper 90 degrees and pull strokes toward you.

4 Pull downward strokes toward you for smooth writing.

Handy Tip: Sandpaper Smoothing

When you are working with handwriting over artwork—but especially with more delicate calligraphy pens—use sandpaper first to smooth down any heavier paint strokes that might catch the tip of your pen. If your project is already fairly smooth, use 400- or 600-grit fine sandpaper (usually black) and sand by hand horizontally back and forth lightly. If you are working on canvas or wood panel or have thick painting strokes or collaged edges of paper, I would recommend using heavier grit sandpaper like 150, followed by medium or fine sandpaper. After sanding, plan on adding back some layers of color that the sandpaper removed.

Variation: Broad Nib Calligraphy Pen Lettering

For a thicker line weight, broad nib pens use the width of the nib to determine the width of downstrokes. There are nibs formed with single piece construction, as well as some that have metal sandwiched together to form a channel for the ink to flow. Take special care when cleaning more complex nibs; you can use a baby wipe for simple pointed pens and single piece constructed broad nib pens. More complex nibs need pen cleaner to get them thoroughly clean, especially if you are using thicker high flow or acrylic inks.

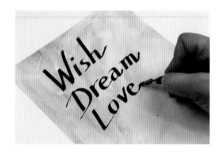

Broad nib pen with Sumi ink over acrylic paint.

Fountain Pens and Parallel Pens

Some writers really like fountain pens or parallel pens, since it is sometimes more convenient to have cartridges filled with ink than have loose ink jars and having to dip and redip your pen. But most fountain pen ink, in order to flow through the nib without clogging, is water based and not permanent. There are a few brands of fountain pen inks that are labeled permanent or lightfast for use on checks and other documents, but the ink will not hold up with a lot of overpainting with gels, paints, or varnish. If you love working with fountain pens, I would suggest using them as the final layer of your artwork without any varnish, gel, or overpainting, which might cause smearing, or do a sample test to make sure. The same goes for parallel pens, which have a nib that is designed with two parallel plates that are sandwiched together. You can use them over artwork, but definitely not underneath, or test for bleeding first. I would also advise against using your favorite gold nib Mont Blanc or Parker fountain pens over painted or collaged surfaces, unless they are very well sanded and clean and dry, since the nib might become damaged.

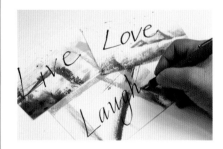

Technique used: Schaefer fountain pen with black ink over lightly painted watercolor postcard.

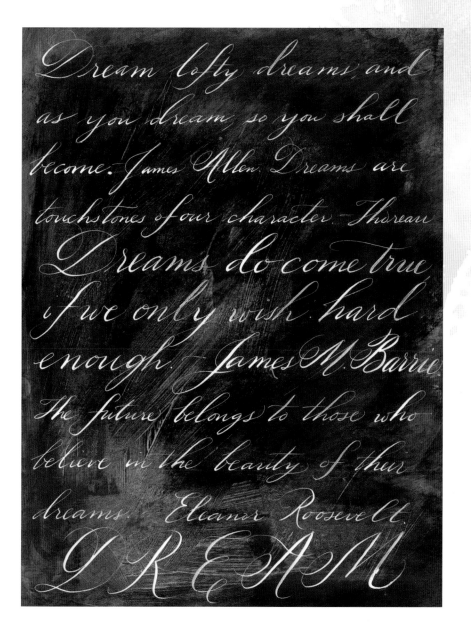

Variation: Dip Pen Calligraphy Lettering in Acrylic Ink

I recommend Daler Rowney's FW acrylic ink if you need something white to show off against a darker background. It is more opaque than high flow. This white ink can work under color washes, but always test different ink colors. I have had mixed reactions and bleeding/smearing with black, but the white is always flawlessly permanent. If you like to have a pastel color of writing, you can write with FW white ink, let it dry, and then do a light wash of red or whatever color paint you'd like to add. It makes for a nice, subtle color. You can also choose to tint white acrylic ink with another color of calligraphy ink. I would stick to the same brand if you are mixing inks.

Dream. Techniques used: acrylic paint on paper (sanded smooth), white FW acrylic ink with pointed dip pen.

1 Practice your layout on scrap paper first with a Sharpie, marker, or your pointed pen and ink.

2 Dip your pen in ink and begin. Wipe off your nib periodically with a damp paper towel and redip to keep ink flowing nicely.

3 Check for spelling errors as you write each line. If you make an error, quickly wipe it off with a damp paper towel or baby wipe before it dries. (Use nail polish remover on dried ink errors.)

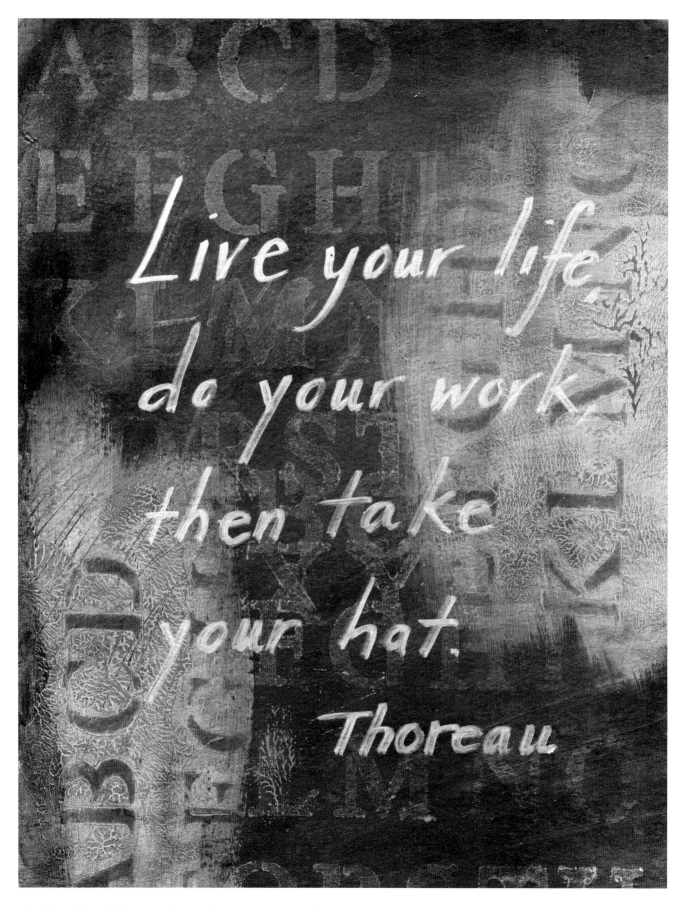

Live Your Life. **Techniques used: stencils and reverse stenciling,**
acrylic color washes on paper, Calligraphie white italic marker.

Pen and Marker Lettering

I typically stay away from permanent markers for health reasons, mostly due to xylene content, which has been proven to be harmful both inhaled and absorbed through skin. But most markers except for a few brands that are labeled archival and waterproof are dye based and therefore subject to fading over time. I try not to do final art with Sharpies but might use them for drawing a guideline on art that will have paint covering it later.

There are many marker pens with calligraphy-style chisels or broad tips. They come in black and sometimes in white, gold, or silver. These are great for writing if you like the broad nib look. The markers are portable and relatively easy to use. Drawbacks with marker pens are that they do run out of ink fairly quickly. Some are the kind that need to be shaken or squeezed for the paint or ink to come up, which tends to create blobs and mistakes. Many markers that are labeled with permanent ink are still reactive to acrylic gel or varnish, so my advice would be to use these as a final layer over painted areas and do not apply any varnish or gel over the top of your lettering, or test extensively before applying to your art. My favorite pen in this category would be PITT pens, since they come in a variety of widths and colors. They are lightfast, waterproof, and archival. PITT pens do have an opaque white India ink pen; however, it is available only in the bold size.

Materials Needed

- artwork, sanded smooth
- Calligraphie white italic marker
- Faber Castell PITT artist black big brush pen
- Faber Castell PITT artist black pen (line width F)
- white water-soluble pencil (use for guidelines with PITT pen)
- ruler, triangle

Live Your Life (close-up).Techniques used: stencils and reverse stenciling, acrylic color washes on paper, Calligraphie white italic marker.

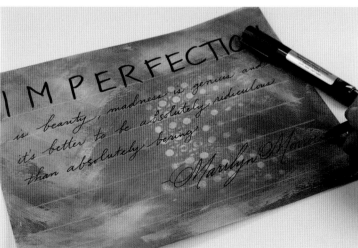

Techniques used: Faber Castell PITT black big brush pen and medium tip pens over painted and stenciled background.

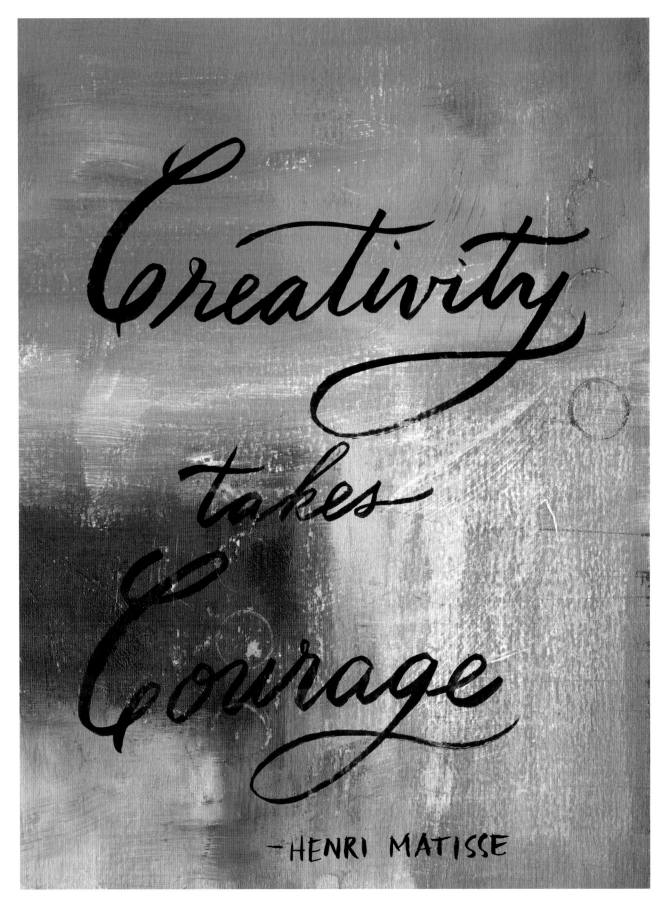

Courage. **Techniques used: acrylic painted background,
Pentel Pocket Brush calligraphy.**

BRUSHED

Brush Pen Lettering

There are several brands of brush pens, many of them from Japanese companies. Depending on what look you are going for, some work better than others. Typical drawbacks of most brush pens is that they do dry out or the tip becomes less pointed. This is great if you are doing rough, brushy handwriting, but not if you want to do perfect cursive. My favorite in this category is the Pentel Pocket Brush, which stays wet and has a nice point for a long time. It also has ink that is waterproof once dry, but typically I will use it as a final layer.

1

2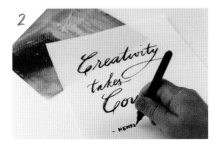

3

4

5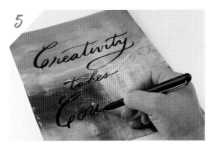

6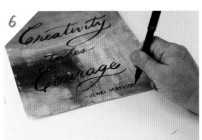

1 Sand your painted art with fine sandpaper, sideways from left to right.

2 Practice your brush calligraphy on marker layout paper. (Do not draw guidelines on your art.)

3 Write directly in freehand cursive or print onto artwork with brush calligraphy pen. If you make a mistake, wipe it off immediately with a baby wipe.

4 For cursive writing, use the brush pen at a 45 degree angle, applying extra pressure on downstrokes, and lightening your hand on upstrokes.

5 Stay relaxed and enjoy the flow of cursive.

6 For block lettering, use the brush pen in a more upright position for thinner, more delicate writing.

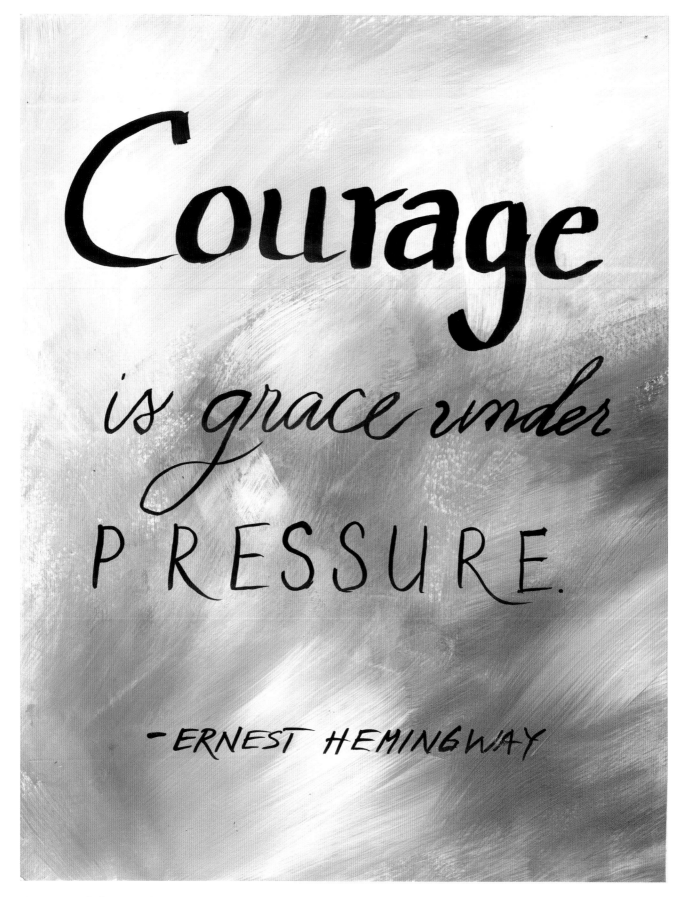

Courage. **Techniques used: brush lettering with black Golden high flow over acrylic painted background.**

Brush Lettering

While an actual brush might not be as convenient as a brush pen, the huge advantage is that you have a wide variety of brush sizes and tips for all different styles of writing. You can work with fat pointed brushes; long liner brushes; old, cheap craft brushes with wandering loose hairs and brand new flat brushes too. There are even brushes that can hold water and can be used with paints or watercolors, or you can fill the barrel with your favorite water-based ink. Whatever style you use, the nice thing is that all of the inks, acrylic inks, high flow paints, and fluid paints will work with all acrylic media brushes.

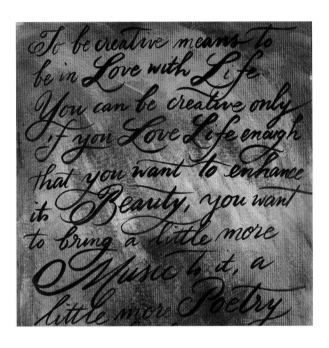

Materials Needed

- painted background artwork
- water-soluble pencil
- ruler
- black gesso, white gesso, or other fluid paint
- Golden high flow
- ¼", ½", or other flat brushes
- pointed brushes or Aquash water brush
- paper towels or baby wipes

To Be Creative (close-up). Techniques used: brush cursive with Pentel pocket brush over painted acrylic.

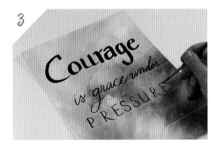

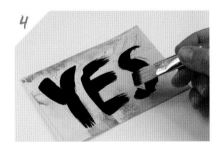

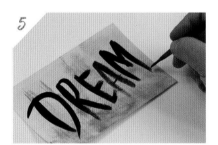

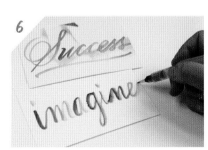

1 **Bold brush printing using high flow and a ¼-inch flat brush.**

2 **Brush cursive with a liner brush.**

3 **Block lettering using a liner brush.**

4 **Block lettering using black gesso or high flow with old 1-inch craft brush.**

5 **Brush lettering using a pointed brush with high flow.**

6 **Brush cursive using Aquash (water-filled barrel brush) dipped in acrylic paints.**

Believe

CREATE

ART

CALM

Love

HOPE

GROW

The Final Details

Many of the tools and mediums demonstrated in this book can of course be used in combination. Whether you are looking for a permanent outline to your hand drawn lettering or merely a way to augment stenciled or stamped lettering, you can reach for a PITT pen to do an outline, or a pointed pen to add a crisp white border with white acrylic ink. Sometimes even just a soft pencil line can be enough to highlight or shadow a letter. A white China Marker on a dark background can create a chalk-like effect. Outlining in black China Marker can create an edge that can be smudged for a softer effect. Whatever methods you decide to use in your art to create lettering, enjoy the process, embrace your mistakes, and allow yourself to play as you make your own painted words.

1 Daler Rowney FW white acrylic ink in pointed pen over acrylic stenciled and painted art.

2 Black China Marker on gel plate-printed postcard.

3 Black China Marker smudged outline over collage and acrylic painting.

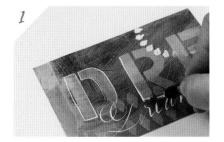

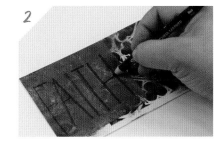

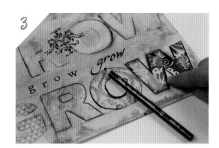

Serendity, Love, Hope. **Techniques used: acrylic on paper, gesso stencils, scribing into wet gesso, frisket resist brush lettering, Faber Castell PITT pen outline.**

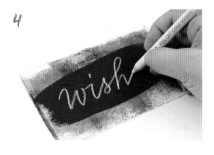

4

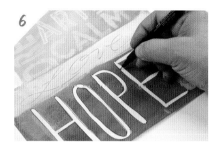

6

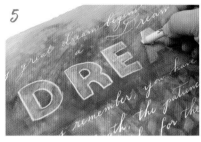

5

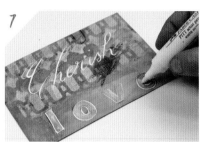

7

4 White China Marker over black gesso.

5 White China Marker outline over acrylic.

6 Black Faber Castell PITT pen outline over frisket resist brushed lettering.

7 White acrylic ink outlined letter with white Faber Castell PITT pen interior fill.

Resources

Many art suppliers also carry calligraphy and stencil supplies, so there are crossovers in this resource guide. John Neal Books in particular sounds like it is just a bookstore, but they carry a huge assortment of calligraphy and general art supplies as well as publish two magazines. I apologize in advance if I have missed any fantastic resources, and encourage you to let me know your recommendations. Some of these online stores have brick and mortar stores too. For those of you lucky enough to have a local art supply store near where you live, I highly encourage you to shop there often. If you are looking for something you don't see on their shelves, ask them. Most local supply stores are more than happy to place a special order for you.

Art Supplies and Resources

Artist & Craftsman Supply
http://www.artistcraftsman.com

Cheap Joe's Art Stuff
https://www.cheapjoes.com

Dakota Art Stores
http://www.dakotaartstores.com

Daniel Smith
http://danielsmith.com

Dick Blick
https://www.dickblick.com

Golden Paints
https://www.goldenpaints.com

Jerry's Artarama
https://www.jerrysartarama.com

Rex Art
https://www.rexart.com

Utrecht Art Supplies
https://www.utrechtart.com

Calligraphy and Pen Supplies and Resources

JetPens
https://www.jetpens.com

John Neal Books
http://www.johnnealbooks.com

Paper & Ink Arts
https://www.paperinkarts.com

Penman Direct
https://www.penmandirect.co.uk

Scribblers Calligraphy
https://www.scribblers.co.uk

Craft, Stencil, and Stamp Supplies

Collage
http://collagepdx.blogspot.com

The Crafters Workshop
http://store.thecraftersworkshop.com

DecoArt
https://decoart.com

Gelli Arts
http://www.gelliarts.com

Gel Press
https://www.gelpress.com

Hobby Lobby
https://www.hobbylobby.com

i stencils
http://istencils.com

Impress Cards & Crafts
https://www.impresscardsandcrafts.com

Jo Ann
https://www.joann.com

Michael's
https://www.michaels.com

P.J. Stencils
http://www.pjstencils.com

Ranger Ink
https://rangerink.com

The Stampin Place
http://www.stampin.com

Stampington & Company
https://stampington.com

Stencil Girl Products
https://www.stencilgirlproducts.com/Default.asp

Stencil Revolution
https://www.stencilrevolution.com

Tsukineko
www.tsukineko.co.jp/english

More Resources: Education and Retreats

Art Is You
https://www.eatcakecreate.com

Art Journaling Magazine
https://stampington.com

Art & Soul Mixed Media Retreats
https://www.artandsoulretreat.com

Art Unraveled
https://www.artunraveled.com

Artmakers Denver
https://artmakersdenver.com

Bound & Lettered Magazine
https://www.johnnealbooks.com

Calligrafile
http://calligrafile.com/suppliers-and-paper

Cloth Paper Scissors Magazine
http://www.clothpaperscissors.com

Create Mixed Media
http://www.createmixedmedia.com

Dasherie Magazine
https://dasheriemag.com

Ephemera Paducah
https://www.ephemerapaducah.com

Flow Magazine
https://www.flowmagazine.com

Letter Arts Magazine
https://www.johnnealbooks.com

Somerset Studio Magazine
https://stampington.com

INDEX